WEST RIDING
PAUPER LUNATIC ASYLUM
THROUGH TIME
Mark Davis

D1612982

AMBERLEY PUBLISHING

Acknowledgements

My thanks must go first and foremost to Gary Brannan and the team at the West Yorkshire Archive Service at Wakefield, for their helpful assistance when studying collections c85 Stanley Royd Hospital and c488 High Royds Hospital.

I am also very privileged to give my special thanks to Councillor Dale Smith, the Lord Mayor of Bradford, for writing the foreword. And not forgetting all the many different people who have contributed to the website www.highroydshospital.com for making it a living, breathing digital archive dedicated to preserving the history attached to this now closed former asylum.

Special mention is made to the memory of the late John Steel OBE. John was not only a founding member and secretary of the Friends of High Royds Memorial Garden, but he was also a true gentlemen. I would also like to thank my good friends Michael McCarthy of the Stephen Beaumont Museum of Psychiatry, Martin Smith of Leeds Deaf and Blind Society, and Tom Booth, former nurse at High Royds Hospital, who has the final word in this book.

Appreciation to Joseph Pettican of Amberley Publishing for his help and assistance once again in compiling my fourth book.

First published 2013

Amberley Publishing
The Hill, Stroud
Gloucestershire, GL5 4EP

www.amberley-books.com

Copyright © Mark Davis, 2013

The right of Mark Davis
to be identified as the Author of this work
has been asserted in accordance with the
Copyrights, Designs and Patents Act 1988.

ISBN 978 1 4456 1750 4

British Library Cataloguing in Publication Data.
A catalogue record for this book is available from the British Library.

Typeset in 9.5pt on 12pt Celeste.
Typesetting by Amberley Publishing.
Printed in the UK.

Foreword

I am delighted to write a foreword for this splendid book focusing on the West Riding Asylums and the wealth of fascinating social history which lies behind the pictures.

Mark Davis has used his extensive knowledge and dug deep into his prodigious picture library to capture in detail the extent and progression of care for people with Mental Illnesses over the life of the West Riding County Council. His detailed research of the people who both lived and worked in some of the institutions concerned has significantly added to our knowledge of past treatments and the isolation of those being treated.

Whilst thankfully modern practices are vastly different in both treatment and concept there can be no doubt that, no matter how misguided we might believe the treatment was in the light of today's knowledge, no expense was spared by the West Riding County Council in providing what it believed was the best.

I thoroughly recommend the book and I am sure that all of us who seek knowledge and insight into the not so very distant past will have many happy hours delving through its pages and ending up very much the wiser.

Dale Smith
Born Four Gables, Horsforth – Menston resident since 1940
Lord Mayor of Bradford 2012/13

Introduction

A knowledge of history is no mere diversion; without it, those fertile avenues of thought which have so often led to innovation and advance must be explored again, and without it the lesson of many a disastrous mistake which should have been learnt will be suffered once more.

Dr R. P. Snaith
Psychiatrist

My initial interest in the social history surrounding the old Victorian asylums came about as a result of my passion for photography. Photographing the magnificent corridors that extended as far as the eye could see at the now closed High Royds Hospital, Menston, I was drawn to research in some small way the thousands of people who had lived out the bulk of their lives in this once bustling institution. For nearly two centuries West Yorkshire, or the West Riding as it was known previously, provided asylum for the mentally afflicted. The word 'asylum' in the true sense of the word denotes a place of safety away from danger. It is clear that in the main this is exactly what the asylums provided for a large proportion of people who would have at best suffered the consequences of extreme poverty and misery and at worst been manacled for many years in some form of primitive madhouse or prison.

Once a familiar feature of the British landscape, the old Victorian asylum was a place where legends were created. They were places of mystery where according to folk, 'all sorts went on'. Even schoolchildren in the playground would taunt each other with, 'You're mental! You're off to Menston', relating to High Royds Psychiatric Hospital. Such phrases as 'going round the bend' originate from the fact that many an asylum, including Menston, could be found at the top of an impressive curved drive, effectively hiding the institution from the prying eye of the general public.

In the nineteenth century, reception into the asylum was potentially the beginning of a life of incarceration in one of many large seventy-bed dormitories. To some it was worse than going to prison; at least with the prison you had a release date, whereas at the asylum there was only a 30 to 50 per cent discharge rate. As a rule the asylum would be located in relative isolation within reasonable distance from the local town and railway. During the latter part of the nineteenth century county asylums were built at a rapid rate to cater for society's intolerance to behaviour and the increasing amount of human wreckage associated with the newly industrialised society. The patient population was drawn primarily from the despised pauper class, although limited numbers of private paying patients were admitted. The majority of paupers were direct transfers from the Workhouse Union (referred to in Bradford by the poor as the 'Bastille') and the magistrates' court upon the recommendation of the police doctor. The patients, or inmates as they were referred to, came from all walks of life, although the biggest percentage were of the unskilled class such as labourers or mill workers. However, it was not unheard of for a policeman or even a schoolmaster to be admitted under the banner of care and treatment. When researching the nineteenth-century patient it soon becomes clear that the noted probable

cause of insanity and how that cause manifests itself can appear worlds apart. For example in the case of Mabel Gray, a young woman of twenty-eight, the supposed cause was 'conflict with husband'; in reality she had GPI (general paralysis of the insane), the conflict being that her husband had infected her with syphilis. Inmates with GPI accounted for a good proportion of the asylum population, as did the manic, the depressed and the intemperate.

Treatment for the Victorian patient ranged from opium as the main sedative in the mid-nineteenth century to laudanum, bromide, and chloral hydrate whilst physical treatment included Turkish or hot baths, wet sheet packs and electric stimulation. Staff were invariably employed from the local population. Thus in time small local towns grew with generations of families being employed. Experience in those early days was not required: quite simply if you were physically fit and either a good sportsman or able to play a musical instrument then you were very likely to be offered a position on the staff.

Although this book is focused upon the West Riding Asylums, similar treatment and management were implemented across the country. By no means claiming to be a comprehensive history, my intention is to give the reader a glimpse at the inner workings of what were in effect self-contained villages for the insane. The text is historical; some terms will appear distasteful by today's standards but were the accepted norm during the relevant period. Times have certainly moved on; the stigma of mental health is a mere shadow of itself in 2012 compared to Victorian intolerance, where families would disown a relative for fear of themselves being labelled insane. Many believed insanity was hereditary.

It is very easy to demonise these institutions but in order to get a better understanding one needs to remove the age-old preconceptions. Certainly it's true that for some people life in the asylum represented a living hell, but for others there came an acceptance and tolerance and with that a quality of life.

In the following pages we begin our journey in time by learning about those early philanthropists who fought tirelessly for their fellow human being and see how their influence made a difference to those who previously had little or no hope.

Although there were four West Riding Pauper Lunatic Asylums, given the logistics of including all four I have concentrated specifically on the ones built at Wakefield in 1818 and Menston in 1888 respectively.

If there is just one thing you do after reading this book, let it be to make a pilgrimage to the Memorial Garden at Buckle Lane, Menston, where 2,861 former patients lay in unmarked graves. It is a place where we can quietly reflect upon the memory of so many, whose lives were quite literally swallowed up in the Victorian ideal for breeding out everything that they feared.

It is wise to remember that no one is immune from mental illness. It can happen in one form or another to anyone at anytime. What is hugely important is that we continue in our drive to break down barriers by wiping out the stigma off this illness. It is through people like Tricia Thorpe, who heads a volunteer group 'Time To Change Leeds', that attitudes are continually being challenged. Her team is determined to make 'discrimination' a term only ever referred to in an historical context.

Mark Davis

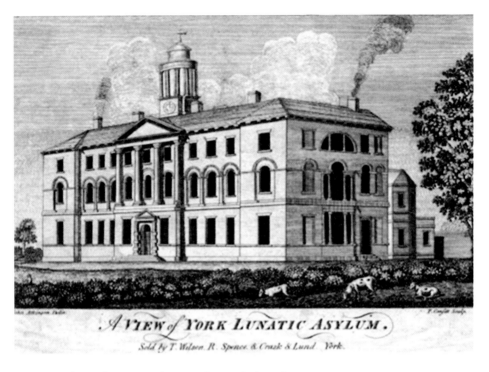

A VIEW of YORK LUNATIC ASYLUM.

Sold by T. Wilson, R. Spence & Crask & Lund York.

York Lunatic Asylum – Bootham Park Hospital, *c.* 1800

In the eighteenth century the plight of the pauper insane was dire at best. Treated no better than animals they were in the main cast out by society, the dangerous chained in despicable conditions while the harmless were ignored and left to cope as best as they could. Although private madhouses had existed for centuries, catering for the poor and affluent alike, these establishments basically traded in lunacy running on a profit basis and without any form of regulation. Into these conditions came the York Asylum, which opened in September 1777, and at the time was one of only a handful of subscription asylums in the country. Although initial intentions were honourable, the potential for easy money was too much for Medical Director Dr Alexander Hunter and his staff, and the asylum descended into being possibly the worst of all the madhouses.

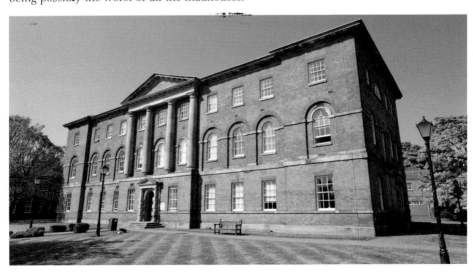

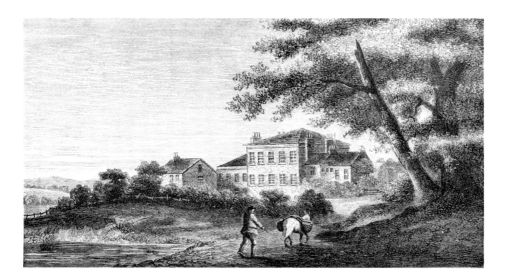

The Retreat, York, c. 1792

In March 1790, Hannah Mills, a young Quaker widow, was admitted to the York Asylum suffering from depression. Hannah was refused all visits from her family and friends and her confinement was shrouded in secrecy; she died on 29 April the same year. Local Quakers were shocked at the events surrounding her death and visited the asylum only to find the inhumane treatment of the inmates beyond comprehension. With this in mind William Tuke set about raising support for building what was to become The Retreat. Tuke's aim was to erect an establishment pioneering the humane treatment of the mentally affected. The Quakers believed, regardless of illness, the 'inner light of God' to be present in all. The Retreat opened in 1796, with the architecture resembling a large house rather than a prison and the moral treatment was based on self-control, compassion and respect. In time The Retreat was to become world famous, as the treatment and regime broke down age-old barriers and welcomed in a new era of reform. Today, in 2012, The Retreat is still administering care and treatment on the same principles and there is a unit named in honour of Hannah Mills, providing assessment and psychiatric rehabilitation for people with complex mental health problems.

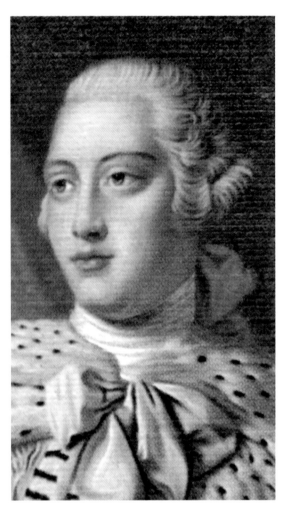

The Wynn's Act, c. 1808

The Wynn's Act or County Asylum Act came onto the statute books in 1808, during the reign of King George III, who himself suffered greatly with mental illness. Under the Act, magistrates were allowed to build and regulate rate-supported asylums in each county for the insane poor. The first county asylum opened in Nottingham; the initial patients, six paupers from St Mary's parish, were admitted on 12 February 1812. Treatments in those early days consisted of emetics (vomiting), purges, bloodletting and blistering. The Wynn's Act was discretionary and despite the population boom during the Industrial Revolution, resulting in the need for more beds, many respective counties were slow to provide places. The 1845 County Asylum Act then made it compulsory for each county in England and Wales to provide asylum for their pauper lunatics. Lord Ashley told Parliament at the time that this would 'effect a cure in seventy cases out of every one hundred'.

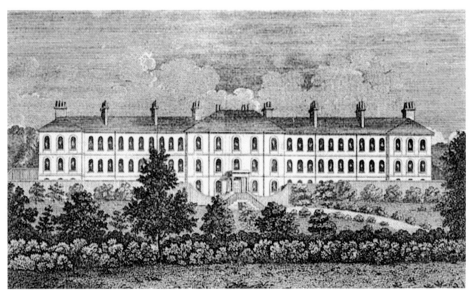

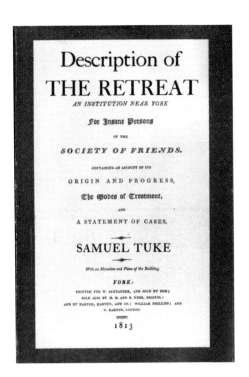

Description of
THE RETREAT
AN INSTITUTION NEAR YORK

For Insane Persons
OF THE
SOCIETY OF FRIENDS.
CONTAINING AN ACCOUNT OF ITS
ORIGIN AND PROGRESS,
The Modes of Treatment,
AND
A STATEMENT OF CASES.

SAMUEL TUKE

With an Elevation and Plans of the Building.

YORK:
PRINTED FOR W. ALEXANDER, AND SOLD BY HIM;
SOLD ALSO BY M. M. AND E. WEBB, BRISTOL:
AND BY DARTON, HARVEY, AND CO.; WILLIAM PHILLIPS; AND
W. DARTON, LONDON.

1813

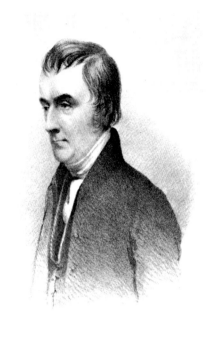

Samuel Tuke, *c.* 1813

Samuel Tuke, born in July 1784, was the grandson of William Tuke who founded The Retreat. In the early nineteenth century, Quaker Samuel devoted himself to mental health reform, quite literally locking horns with Dr Charles Best, who by then had become the Medical Director of the York Asylum. It was through Samuel's publication, *Description of the Retreat: An Institution Near York,* that the humane treatment practised there became renowned across the world. People travelled from far and wide to witness the moral treatment (borrowed from the French *traitement moral,* used to describe the work of Pussin and Pinel in France) at The Retreat where mechanical restraint had been replaced with human kindness and understanding. In effect The Retreat was instrumental in striking off the chains and bringing light to so many patients, when before there had been only darkness. Buried in the cemetery at The Retreat in October 1857, Samuel left two sons, James Hack Tuke and Daniel Hack Tuke, who continued in their father's pursuit of humanitarian idealism.

Godfrey Higgins – Magistrate

As Samuel Tuke's battle with Dr Charles Best at the York Asylum appeared to lose momentum in 1813, Godfrey Higgins, a magistrate from Skellow Grange near Doncaster, stepped into the frame. Higgins had recently sentenced William Vickers, a simple labourer, to six months at York Asylum for assault, only to be thoroughly outraged at his treatment within the institution. Upon Vickers' release a surgeon found him 'itchy and extremely filthy' with his health much impaired; one of his legs was in a state of mortification. There was also evidence of Vickers being chained and whipped, prompting Higgins to write to the *York Currant* expressing his concerns at the treatment meted out to Vickers. The newspaper, however, instead of printing Higgins' letter, handed it to Dr Best at the York Asylum and so began an alliance between Samuel Tuke and Higgins. Together they courageously exposed the horrific plight of pauper lunatics at the York Asylum, bringing a catalogue of serious abuses to the attention of a Parliamentary Select Committee in 1815. As a result of their tireless efforts, their evidence was instrumental in the committee bringing in sweeping reforms countrywide. Godfrey Higgins died in August 1833 and was laid to rest at Wadworth parish church near Doncaster.

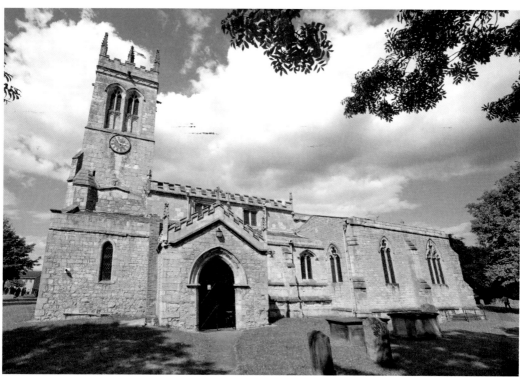

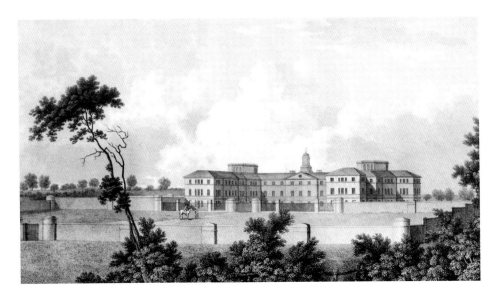

Wakefield Asylum, *c.* 1818

As a consequence of the abuses at the York Asylum, Godfrey Higgins was able to persuade fellow magistrates to take advantage of the 1808 Wynn's Act and build an asylum under their control, which was resolved at the Michaelmas General Quarter Sessions held in Leeds in October 1814. The magistrates sought out the best designs for such a building, offering one hundred guineas for the winning design and a further £750 to superintend the construction. Samuel Tuke was employed to draw up a basic set of requirements for the guidance of the competitors. John Foljambe, clerk to the Visiting Justices, laid the foundation stone just six months after the Battle of Waterloo on 1 February 1816. The asylum was built to the designs of Messrs Watson & Prichett of York, whose H-shaped design in brick, as plain and unornamental as is consistent with propriety and neatness, was judged the best out of forty plans submitted. By November 1818 the first West Riding Pauper Lunatic Asylum, built at a cost of £36,448, was judged ready for the reception of up to 150 patients. The new asylum was administered by the magistrates until 1889 when responsibility for all asylums was transferred nationally to the relevant local county council.

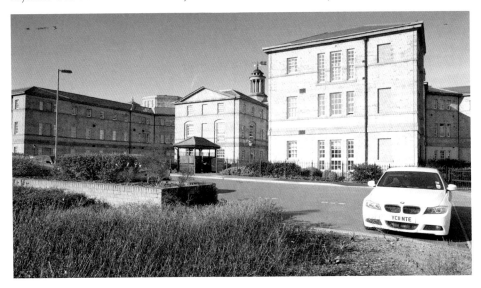

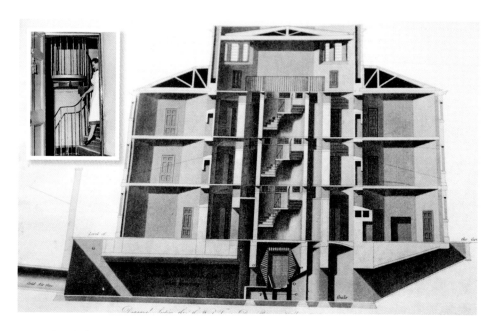

Samuel Tuke's *Practical Hints*, c. 1819

It is with much gratitude to Lawrence Ashworth, former hospital secretary, that an original copy of Tuke's *Hints* came to light. Whilst searching out an old sideboard at the former asylum he discovered a secret drawer holding the book containing a number of plates, plans and sectional drawings relating to the original construction of Wakefield Asylum. Although compiled in 1814, the book was not published until 1819. Pictured is a cross-section diagram of the west tower. Tuke regarded vigilant supervision of the patients extremely important, referring to it as 'espionage'. He included the spiral staircase that allowed secure yet unobtrusive observation of all the wards to ensure that patients were not abused. The later image, taken prior to modernisation in the early 1960s, gives us a clear picture as to how this design was not only successful but also stood the test of time. Tuke also suggested setting up a weaving industry for patients to both learn a trade and work in. This early form of occupational therapy was taken up most enthusiastically.

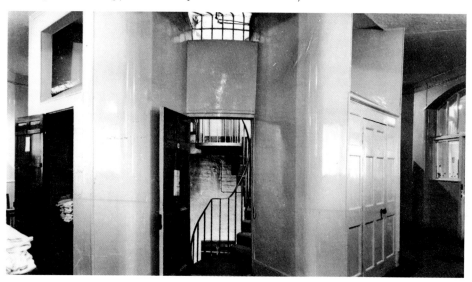

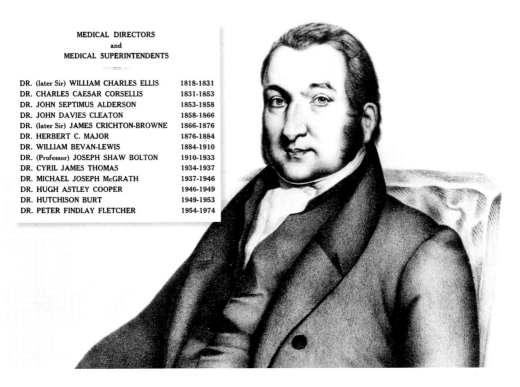

MEDICAL DIRECTORS and MEDICAL SUPERINTENDENTS	
DR. (later Sir) WILLIAM CHARLES ELLIS	1818-1831
DR. CHARLES CAESAR CORSELLIS	1831-1853
DR. JOHN SEPTIMUS ALDERSON	1853-1858
DR. JOHN DAVIES CLEATON	1858-1866
DR. (later Sir) JAMES CRICHTON-BROWNE	1866-1876
DR. HERBERT C. MAJOR	1876-1884
DR. WILLIAM BEVAN-LEWIS	1884-1910
DR. (Professor) JOSEPH SHAW BOLTON	1910-1933
DR. CYRIL JAMES THOMAS	1934-1937
DR. MICHAEL JOSEPH McGRATH	1937-1946
DR. HUGH ASTLEY COOPER	1946-1949
DR. HUTCHISON BURT	1949-1953
DR. PETER FINDLAY FLETCHER	1954-1974

Wakefield Asylum – Sir William Charles Ellis, Medical Director 1818–31

'In A Well-Regulated Institution, Every Means Ought To Be Invented For Calling Into Exercise As Many Of The Mental Faculties as Remain Capable Of Employment...' (William Charles Ellis)

In December 1817 it was unanimously agreed that Mr and Mrs Ellis be appointed Director and Matron of the new Wakefield Asylum at a joint salary of £250 a year, with effect from January 1818, although it would be 23 November 1818 before the reception of the first patients – a year and five months behind schedule. Mr and Mrs Ellis, who were devout Methodists, regarded the asylum as a community. They referred to staff and patients as a 'family', of which they were the heads. Medicine, Ellis claimed, was the least important part of treatment; what mattered most was moral treatment. Patients were engaged in useful employment around the asylum and the reward of a little tea, tobacco, beer or some other luxury was used to induce them to work in wards, workshops or grounds. The Ellis's left the Wakefield Asylum in January 1831, just as the new East Wing was completed, having been appointed Director and Matron at the newly-built Hanwell Asylum in Middlesex.

Ellis was responsible for establishing both the Harrison fund at Wakefield and the Queen Adelaide fund at Hanwell. The charitable funds were created to assist in the rehabilitation of patients upon discharge. Ellis recognised the difficulty faced by patients when released back into the very circumstances that had often created the illness in the first place. Determined by circumstance, funds were provided to clear debt, purchase tools to work with, etc., in the hope that the patient would have a good chance of avoiding both relapse and readmission at a later date. In his *Treatise on Insanity*, published in 1838, he wrote:

> But something further is still wanted. A comfortable place where patients might find food and shelter and a home until they could procure employment would be an invaluable blessing ... Many patients might thus be eventually restored to society who are now compelled to remain in the asylum in consequence of their retaining some erroneous view on some unimportant matter.

In 1835 William Ellis was knighted for his services to the insane.

13

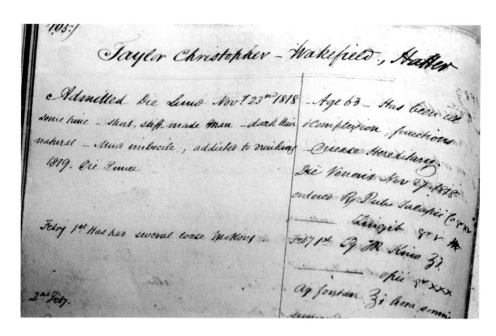

Wakefield Asylum – Christopher Taylor, *c.* 1818

Although the name 'Mad Hatter' was clearly inspired by the phrase 'as mad as a hatter', the origin of this phrase possibly relates to Christopher Taylor, a 'hatter' who was the first person to be admitted to the Wakefield Asylum on 23 November 1818, along with three other men and four women. Mercury was used in the process of curing felt in some hats, making it impossible for hatters to avoid inhaling the mercury fumes given off during the hat-making process. Mercury poisoning causes neurological damage including confused speech and distorted vision. From day one of the opening a strict rule of the asylum was the complete segregation of the male and female inmates, which continued until the 1960s when the old asylum had become Stanley Royd Hospital.

MADDENING!

(still more apologies to Lewis Carroll)

West-Riding
or } To wit.
Yorkshire.

To *the Overseers of the Poor of* *Barnsley*
in *the said Riding, to convey; and to the Director or Keeper of*
the Lunatic Pauper Asylum, at Wakefield, in the said Riding, to
receive and obey.

WHEREAS Information on Oath hath this Day been made unto me, One of His Majesty's Justices of the Peace in and for the said Riding, by *David*

an Agent to the Overseers of the Poor of *Barnsley*

in the said Riding, that *Martha Wild*

is a Pauper Lunatic, Insane Person, or Dangerous Idiot, belonging the said Township

of *Barnsley* and whereas the said Overseer having at

the same Time produced to me the said Justice, the Certificate of a medical Person, respecting the State and Degree of Lunacy, Insanity, or Idiotcy, of the Pauper on whose Behalf such Application is made, and craved my Warrant to convey such Person to the Asylum for Lunatic Paupers, at Wakefield, in and for the said Riding.

Wakefield Asylum – Martha Wild, c. 1819

When the new asylum at Wakefield opened it was the sixth asylum to be built under the Wynn's Act, put into place to protect the insane, and in many cases to remove them from unsuitable conditions within the workhouse. There was, however, a problem. The cost of housing a person in the workhouse was much cheaper for the Workhouse Union to bear than the asylum. Throughout his term William Ellis campaigned for the workhouses to send him their insane poor expediently. Ellis argued that if a person was sent to him at the onset of illness there was a high chance of cure whereas the workhouse was more inclined to send their insane only when chronically ill and unmanageable. He quite rightly pointed out that patients sent when all hope was lost were ultimately a more expensive option, as the patient required long-term palliative care. A classic example is seventy-nine-year-old Martha Wild, admitted in 1819, who had spent thirty-six years chained to a wall in the Barnsley workhouse. After just six months under the care of William Ellis the hapless patient had improved to such an extent that she was usefully employed on the ward repairing sheets. She was, however, incapable of ever leading a normal life again.

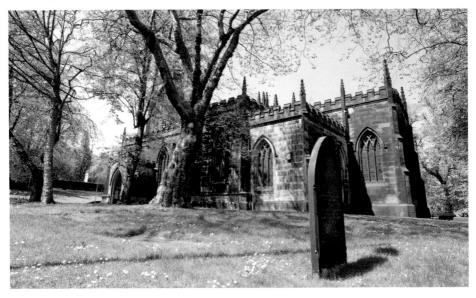

this morning & has been picking up some stones with some patients in the garden the fear of going into the circular swing which she had heard of induces her to work.

Aug.st 8th Has continued much the same since last report. This morn-

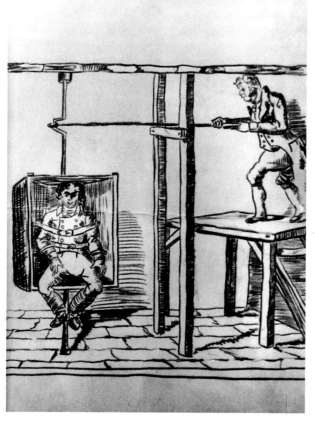

Wakefield Asylum – the Spinning Chair, *c.* 1818
One of the earliest and short-lived treatments at the Wakefield Asylum was the spinning chair, where the speed of rotation was placed under the command of the attendant by means of a crude yet effective crank. Although it was noted that the chair gave 'wonderful good effects', such was the terror that the machine evoked in Sarah Musgrove (and others) that the mere mention of it induced her to work. Other early forms of physical treatment included manual labour as the cornerstone of recovery. As far as possible all inmates/patients were employed within the asylum to the best of their ability. William Ellis, however, considered kindness to be the overruling essential ingredient to recovery where the patient would be encouraged to apply their own control rather than implementing some of the harsh physical controls previously thought essential.

Dr Caleb Crowther, 1818–28

Immediately upon hearing about the planned asylum at Wakefield, Dr Caleb Crowther offered his services as the Honorary Visiting Physician. He commenced on 23 November 1818, assisting with the very first intake, and held this position with distinction until his resignation in 1828. Throughout this period Caleb became increasingly unhappy with the administration of the asylum, believing William Ellis had too much control over not just the management of the asylum, but also the medical care in general. So strongly did he feel about this that he petitioned the Houses of Parliament recommending the appointment of a Minister of Health and a form of inspection providing regular visitation and supervision of all asylums. It is through Dr Crowther that some years' later legislation was implemented and remained in force for over a century very closely in accordance with his recommendations. His grave can be found close to the almshouses he built for poor nonconformists in George Street, Wakefield.

OBSERVATIONS

ON THE

MANAGEMENT

OF

MADHOUSES.

PART THE THIRD.

WITH AN APPENDIX,

CONTAINING MEMORANDA ON MEDICAL PRACTICE.

By CALEB CROWTHER, M.D.

FORMERLY SENIOR PHYSICIAN TO THE WEST-RIDING
PAUPER LUNATIC ASYLUM.

London:

SIMPKIN, MARSHALL, AND CO.

1849

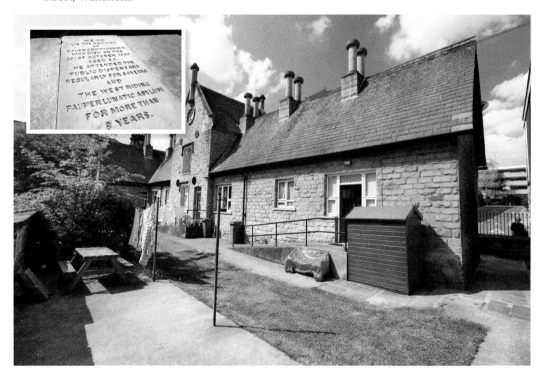

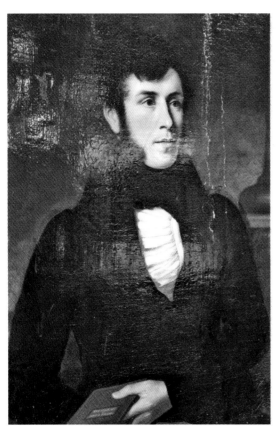

Wakefield Asylum – Charles Corsellis, Medical Director, 1831–53

Upon the departure of the Ellis's in 1831 Dr Charles Caesar Corsellis and his wife took up the position of Medical Director and Matron of the asylum. The first year of office was one of turmoil: his three-year-old son died of dysentery, a disease that was then all too common. Undoubtedly Corsellis greatly admired his predecessor by closely following his principles in managing both the administration and medical requirements of the fast-expanding institution. During his term, essential additional accommodation to the original 'H' block design was added, with a West Wing in 1841, as well as the centre of the 'H' design being expanded to provide a house for the Director in 1843, as seen in the later image. Upon the sudden resignation of Charles and his wife in 1853, the joint position of Director and Matron was discontinued forever, possibly as a result of Caleb Crowther's previous comments regarding the evils of a joint appointment.

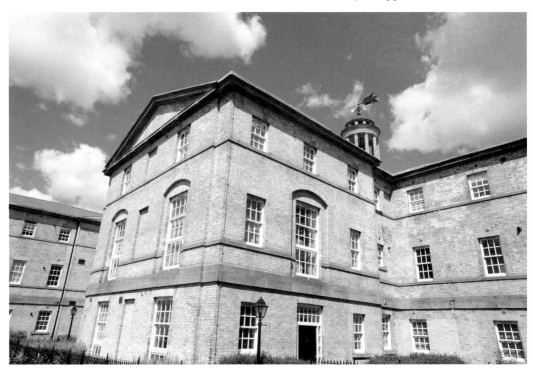

Cholera in Wakefield Asylum, *c.* 1849
During the directorship of Charles
Corsellis, the institution was to endure
a serious outbreak of pestilential
cholera, which wiped out a sixth of
the population. Although in 1832
the asylum escaped the countrywide
epidemic that claimed fifteen lives in
Wakefield alone, another outbreak in
the autumn of 1849 claimed the lives
of 106 of the 620 patients between
October and December. Such was the
scale of the disease that the visiting
physician, Dr Thomas G. Wright, MD,
prepared a special report detailing the
origin and progress of the outbreak.
During the same period a further
twenty-one deaths from dysentery
and ten from diarrhoea occurred, the
dead being buried in pauper graves at
the local Stanley churchyard in land
previously purchased by the asylum.

REPORTS

ON

THE ORIGIN AND PROGRESS

OF

PESTILENTIAL CHOLERA,

In the West-Yorkshire Lunatic Asylum,

DURING THE AUTUMN OF 1849,

AND ON

THE PREVIOUS STATE OF THE INSTITUTION.

A CONTRIBUTION TO THE STATISTICS OF INSANITY AND OF CHOLERA.

BY

THOMAS GIORDANI WRIGHT, M.D.,

VISITING PHYSICIAN TO THE ASYLUM;
MEDICAL VISITOR OF LICENSED HOUSES FOR THE INSANE IN THE WEST-RIDING;
PHYSICIAN TO THE WAKEFIELD HOUSE OF RECOVERY, &c.

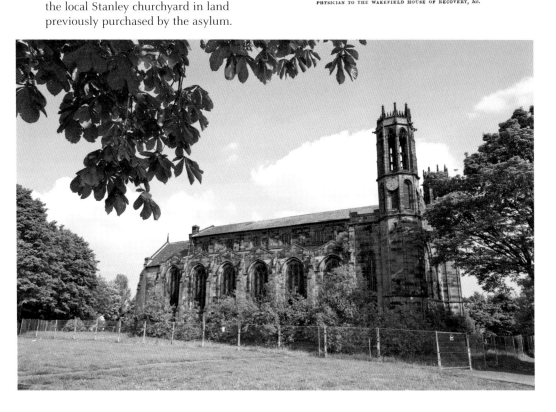

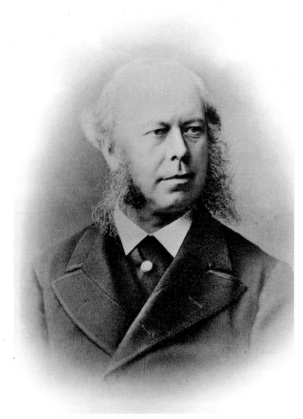

Wakefield Asylum – John Davies Cleaton, Medical Director, 1858–66
Following the resignation of Charles Corsellis, the appointment of Director was taken up by the former Medical Superintendent of the Nottingham Asylum, John Septimus Alderson, who held the post until he resigned in October 1857 due to ill health. Dr J. D. Cleaton, former Superintendent of Rainhill Asylum, who beat seven other applicants, took up the role in April 1859. Cleaton, regarded as a brilliant hospital administrator, commissioned a patient, a former draughtsman, to create a perspective drawing of the whole institution. The patient duly carried out the task by climbing trees in order to get a greater view. So accurate was the drawing that a Leeds firm of lithographers was employed to transfer the image to a piece of marble.

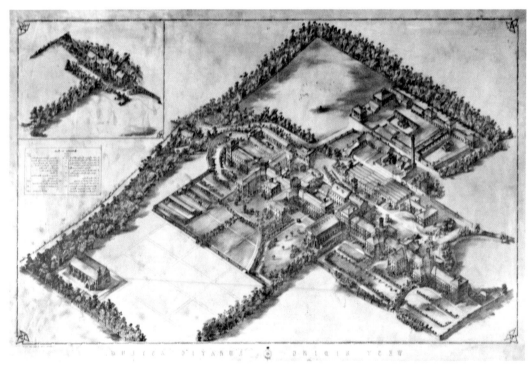

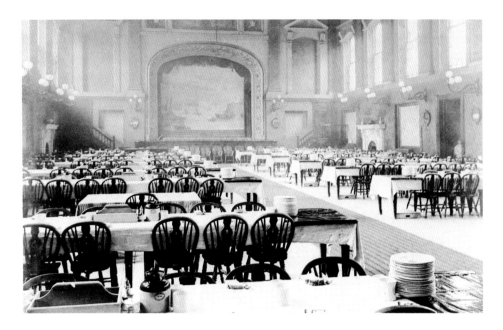

Wakefield Asylum – Recreation Hall, *c.* 1900

When the opening of the male dining hall and recreation hall occurred in 1861 a new chapter in the patients' lives opened. Asylum life was at best monotonous and plays performed in the hall were a welcome break from the drudgery of the strict, clock-controlled routine. Pictured at the turn of the twentieth century the hall set for lunch presents an image of order; by each spoon there is one slice of bread for the usual meat and potato lunch. Although patients were supplied with crockery and knives and forks, no one left the dining hall before all items were accounted for. The hall was the scene of many fine performances including W. S. Gilbert's classical drama *Pygmalion and Galatea* performed in 1875 when Gilbert himself took part, the first time he ever performed as an actor. In 2012 the hall is the setting for the 'Destiny Church', which has sympathetically restored the period building.

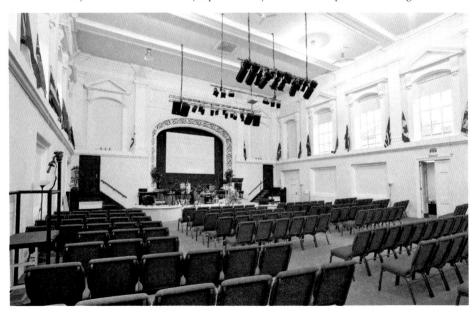

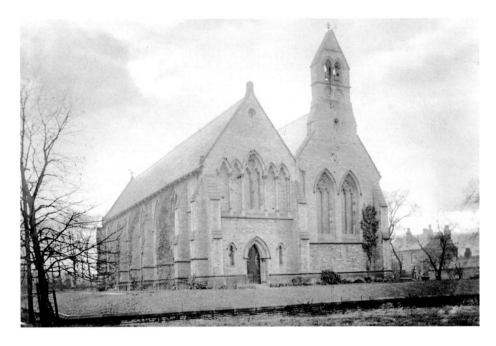

Wakefield Asylum – St Faiths in Hospital, *c.* **1868**
When the asylum opened in 1818, Medical Director William Ellis personally carried out religious affairs in the original 'H' block until the Lunatics Act of 1828 when Revd Naylor was appointed and held the post until 1843. In later years the room used was converted into a dormitory attached to ward 5, appropriately known as the 'Chapel Dormitory'. A glass case displayed the original bible used, with the pages being turned daily for the benefit of the patients. As the population of the asylum grew rapidly so did the need for a suitable place of divine worship. The asylum chapel, built in a Gothic Revival style, opened in October 1861, under the directorship of John Davis Cleaton, and was a virtual replica of the church built by the Great Northern Railway in Doncaster, designed by Sir Gilbert Scott. Seen in summer 2012, the old chapel was subject to an arson attack soon after the picture was taken.

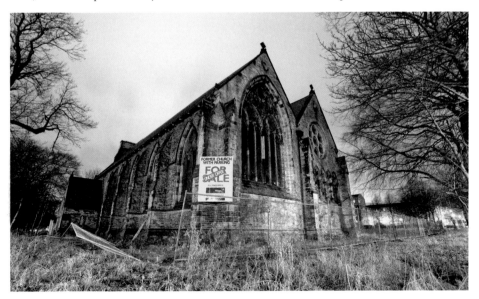

Stanley Royd Hospital –
St Faiths in Hospital, *c.* 1961

By 1961 Wakefield Asylum had been renamed Stanley Royd Psychiatric Hospital. On the centenary of the asylum chapel opening a service of thanksgiving took place in April 1961, officiated by the Lord Bishop of Wakefield, Right Reverend J. A. Ramsbottom, at which time the new east window was dedicated. The window – the only one of its type in the world – depicted 'The Healing Christ' with his disciples around him healing people. Around the central picture were represented figures from the modern hospital team, the hospital chaplain, a doctor, a nurse, a member of the administrative team, a member of the maintenance staff and a chef. Alas, as a result of repeated acts of vandalism the window was destroyed recently, as depicted on the next page.

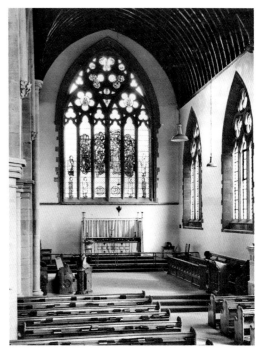

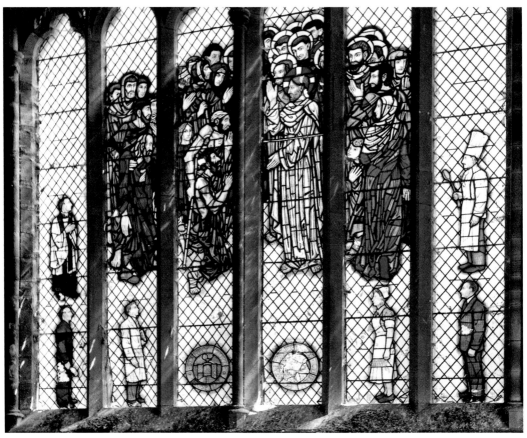

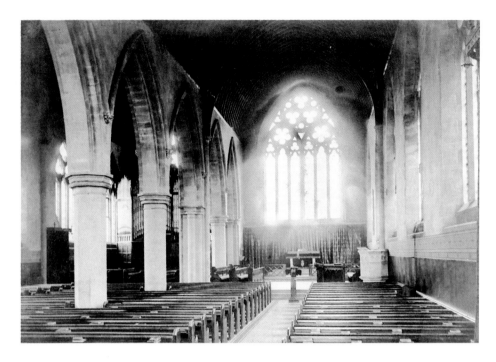

Wakefield Asylum – St Faiths in Hospital, *c.* 1899
Described as the heart of the asylum, the chapel situated a short distance from the original 1818 building offered quite literally the true definition of 'asylum': a place of peace and refuge away from the overcrowded wards. Pictured in 1899, the chapel could house 600 patients who regarded their permission to attend as a great privilege. The seating allowed for the segregation of both males and females, even having separate entrances. Within two years of opening the organ was added, allowing the performance of musical concerts of famous composers by both the asylum and local choir. The final service was held on 9 April 1996 when patients and staff said a final farewell to the hospital church of St Faith. Sadly, this one-time haven of peace is now a charred shadow of its former glory awaiting demolition.

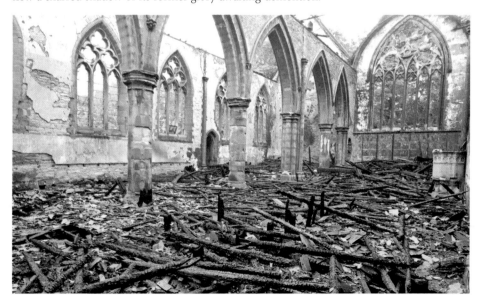

Wakefield Asylum – James Crichton-Browne, Medical Director, 1866–76
Known as the 'Orator of Medicine', as far as dynamic medical management of the asylum was concerned, the appointment of Crichton-Browne (later Sir James) in 1866 heralded the 'Golden Age' of Wakefield Asylum. Crichton-Browne without doubt was a gifted and enthusiastic Director, gathering in an eminent team of neuropsychiatrists including Hughling Jackson and David Ferrier, as well as appointing a pathologist believed to be the first to be appointed to an asylum in the country. Working closely with Charles Darwin, who was working on the book *Expression of Emotion in Man and Animals* at the time, Browne forwarded him images of asylum patients to aid in the research. Knighted for his pioneering services to medicine, Crichton-Browne's memory is very much linked to a period in medical history when neurology became a science. Pictured below is the pathology lab at Wakefield Asylum, *c.* 1898.

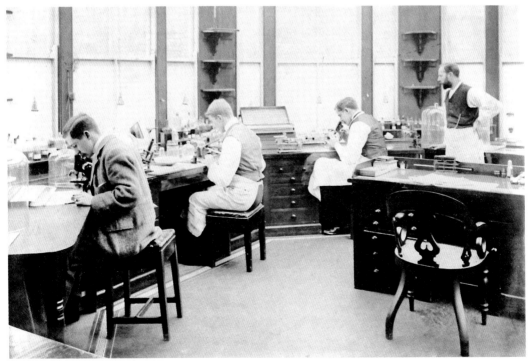

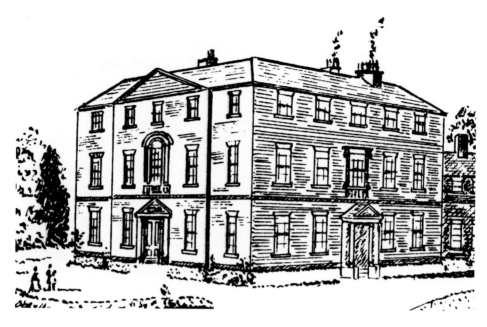

Mount Pleasant, Sheffield, *c.* 1868

Always a continual problem, overcrowding was one of the first issues for Crichton-Browne to deal with upon his appointment. Expanding the asylum at that time was thought impracticable when considering there was 1,124 patients occupant in 1866; it was felt that expansion would be detrimental to both patients and staff. Therefore, it was decided to open a second West Riding Asylum. Wadsley, in the South Riding, was chosen as a suitable site. In the meantime a temporary measure was found by the acquisition of a five-year lease of Mount Pleasant close by on Jarrow Lane. Mount Pleasant allowed for the transfer of up to 190 chronic but quiet and harmless patients from Wakefield, easing the burgeoning asylum population. Dr Mitchell, Medical Assistant, superintended Mount Pleasant until its closure in August 1872, being rewarded by his appointment as Medical Superintendent of the new Wadsley Asylum.

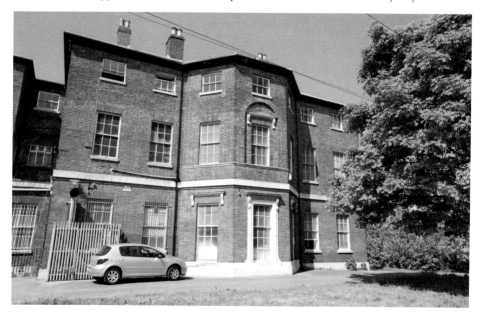

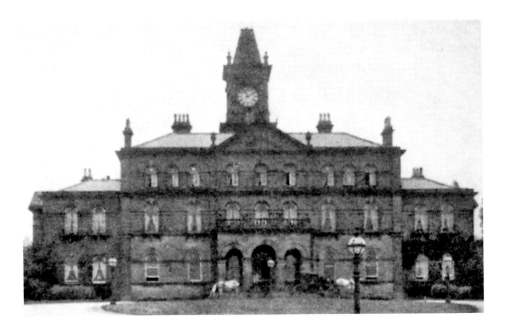

Wadsley Asylum, c. 1872

The summer of 1869 saw the construction of the second West Riding Pauper Lunatic Asylum begin. Lord Wharncliffe announced the approved plans for accommodation totalling 750 beds, although this would expand greatly over time. Despite completion in 1871, the reception of the first seven patients, all transfers from Wakefield, did not take place until August 1872. Described as the most imposing structure near Sheffield, the institution when built was very much isolated in a rural setting. The asylum, later named Middlewood Hospital, served the community for some 124 years before closure. The site, demolished to some extent, is now converted into contemporary housing like many former asylums countrywide, although the church remains in a derelict condition. Pictured is the administration block which still stands.

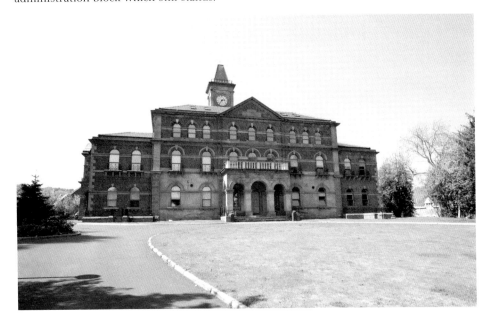

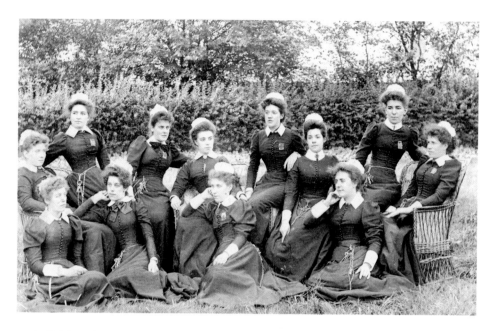

Wakefield Asylum – Nursing Staff, *c.* 1895

By 1895 there were three West Riding Pauper Lunatic Asylums providing care and treatment for the insane poor, although the joint asylums also took in limited numbers of private patients. The charge for a private patient (the cost borne by the patient or family) ranged from £1 a week to 14*s* depending on the individuals' circumstances. Once a patient's savings or income was depleted the patient would be transferred to the pauper class books. Conditions between the two classes were little different with the exception of a little extra butter for the private patient. Pictured in 1895 are the female nursing staff from Wakefield Asylum; there were 70 in total caring for 695 female patients. Note the heavy key chains about their waists. On the male side there were 65 attendants in attendance caring for 703 male patients under the directorship of Dr Bevan Lewis and four medical assistants including one pathologist.

Wakefield Asylum – Dr William Bevan Lewis, 1875–1910

By 1875, when Dr Bevan-Lewis joined Wakefield Asylum, the institution had already gained an enviable reputation for the psychological study of lunatic patients. Treading in distinguished footsteps, Bevan-Lewis was quickly promoted to Pathologist and then Deputy Medical Superintendent before finally becoming Medical Director in 1884. Holding the post for twenty-six years, one of his many achievements – despite strong prejudice in medical circles to the segregation of recent and new cases from the long-term mentally ill – was to open a separate acute hospital. Later known as Pinderfields Hospital and built very close to the old Wakefield Asylum, the official opening took place on 8 March 1900. The new 'Acute' was extremely well equipped for its time with light and airy accommodation, a state-of-the-art pathological laboratory and research facilities. Although all new and recent cases would be admitted to the acute hospital with a view to an express cure, many of the patients were ultimately transferred to chronic blocks at Wakefield Asylum. Dr Bevan-Lewis (seated on the right) is seen in the earlier image. In the later image Pinderfields Hospital is shown in 2008 prior to its demolition.

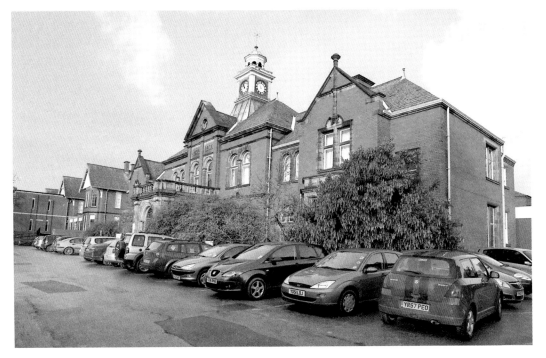

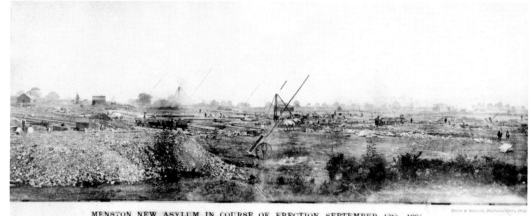

MENSTON NEW ASYLUM IN COURSE OF ERECTION, SEPTEMBER 13th, 1884
WHITAKER BROTHERS, CONTRACTORS, HORSFORTH.

Menston Asylum, c. 1884

As the influx of people moving to the industrial North of England and the population boom increased in the mid- to late nineteenth century, so did the volume of human wreckage of this newly industrialised society. The need for more beds was as ever a pressing problem. Despite Wadsley Asylum opening just over a decade earlier it was decided to build the third West Riding Pauper Lunatic Asylum at Menston with work commencing in the early 1880s. Pictured in 1885 is Herbert Martin's artist's impression of how the new asylum would look, including an impressive church that was never built. Menston was the only asylum in the country, up until 1904, without a separate place for divine worship, which at the time was considered by the Commissioners of Lunacy as quite deplorable. Shown above is the building in progress in 1884. Whitaker Brothers of Horsforth, employed to construct the asylum, transported stone and other materials via the train seen in the middle distance.

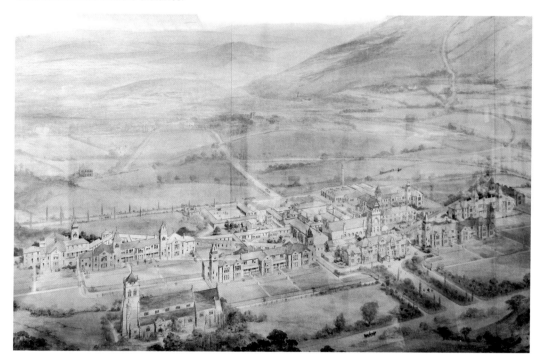

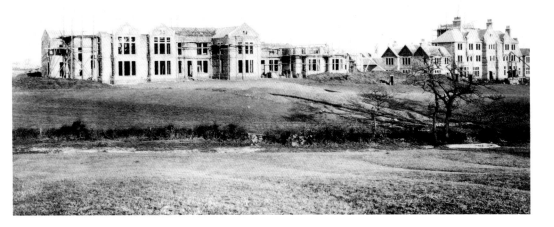

Menston Asylum, c. 1886

'The fact that the work will at the time of the opening have required continuous labour for three and a half years; that at times that 500 work people have simultaneously employed in the undertaking; that the corridor in the central block is 239 feet long and that from its range corridors on each hand no less than 420 feet long and that the buildings and pleasure grounds have absorbed 24 acres of the estate will indicate the immensity of the institution which has been placed so conveniently in relation to the populous parts of the Riding, and with all in so happy a situation in respect of health and beauty. The whole of the exterior is in stone from the Horsforth quarries, with Pier points of stone from Idle. The buildings are plain and substantial in the architectural details, but as seen in the mass from the distance they present an imposing appearance' (*Ilkley Gazette*, 1888). Pictured are original images taken in 1886, as the build was halfway to completion.

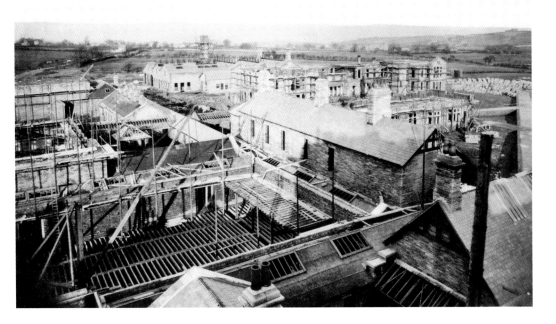

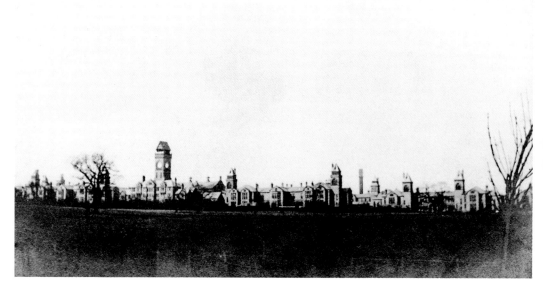

Menston Asylum, *c.* 1906

'The new asylum stands at the foot of Rombalds Moor, upon an estate, which was purchased for nearly £18,000 from Mr. Ayscough Fawkes, (a descendent of Guy Fawkes) of Farnley Hall. The estate slopes gently from a height of 694 feet to 420 feet above the sea level. The institution is built with a large administrative block at the centre, crowned by a noble clock tower; and the various departments stand transversely to the wings on either hand. The whole presents a southern elevation of more than three-fifths of a mile in extent. The façade, however, is further relieved by smaller towers, which rise above the different blocks, and serve for ventilation and other essential purposes.' (*Ilkley Gazette*, 1888)

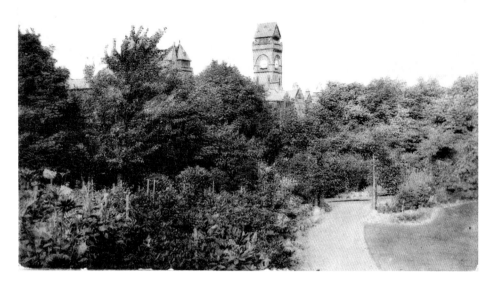

Menston Asylum, *c.* 1888

After years of construction the new asylum was to take in its first thirty female inmates on 8 October 1888, all transfers from the overcrowded Wadsley Asylum, Sheffield. Elizabeth Johnson, the first woman to enter the asylum, died on 15 February 1904 and was laid to rest in Row 5 Grave 13 of the asylum cemetery in Buckle Lane. The first sixty-one admissions were all female. It would be November before the male patients began to arrive, again transfers from Wadsley. Originally the institution was known as the West Riding Pauper Lunatic Asylum, Menston. By the 1920s the reference to paupers and lunatics had been dropped, becoming Menston Mental Hospital before eventually gaining the title High Royds Psychiatric Hospital in 1963. The administration building/clock tower is probably the finest and most ornate structure of its type built in the entire country.

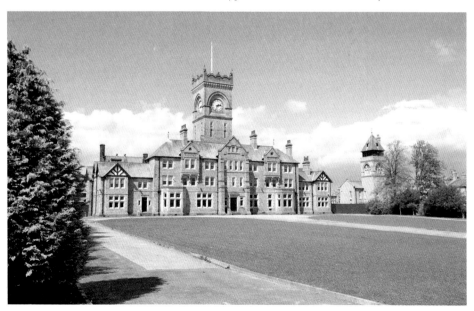

Menston Asylum – Central Corridor, c. 1905

Described in detail in 1888: 'The entrance hall to the administrative block is flanked by committee rooms, magistrates' rooms, residences and offices for the medical superintendent, the matron, medical officers and assistant medical officers; apartments for the clerk and steward, a library, a surgery and dispensary, and separate waiting rooms for male and female visitors, with entrances from a transverse corridor, into which also the entrance hall opens. The hall is floored in mosaic, with a centrepiece representing the White Rose of York. Its width of eighteen feet is prettily relieved by dados of Burmantofts falence and windows, framed in the same material, which are filled with choice stained glass.' In the later image the war memorial can be seen hung on the wall at the very end of the corridor. Sadly this was stolen in 2009 and never recovered.

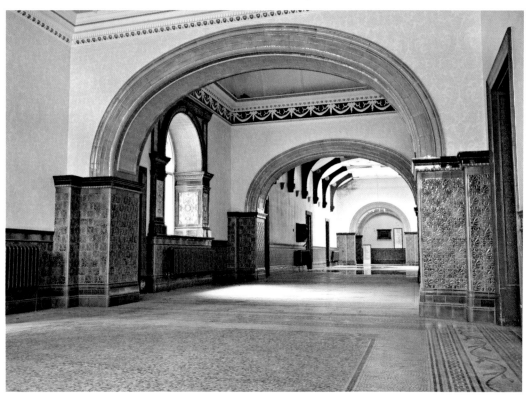

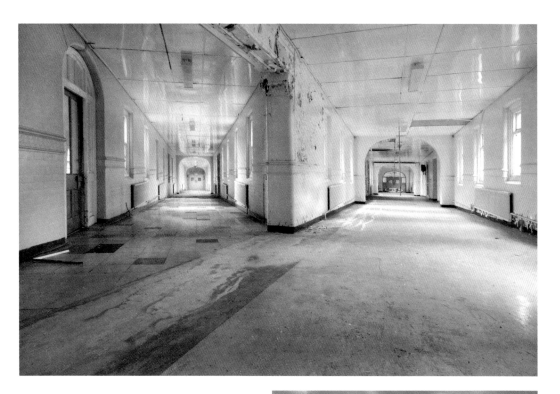

Menston Asylum – the Broad Arrow Corridor System

Designed by J. Vickers-Edwards, the original asylum was built upon the broad arrow echelon system. The wards, set in detached pavilion blocks, were linked by small, stubby corridors to the whole hospital via the extensive main corridor, which stretched through both the male and female segregated sections. The benefit of this corridor plan was the ability to separate all classes of patients whilst effectively making the institution fireproof, in that flames could not possibly spread from one pavilion block to the next. Shown above in 2008 the dual-aspect corridor was a singular unique feature of this plan. Prior to the recent demolition of linking corridors, High Royds (Menston Asylum) was considered to be the finest example of this broad arrow system. In the 2005 film *Asylum* the corridor features in the opening credits. The film crew added an arched gate which was removed after filming.

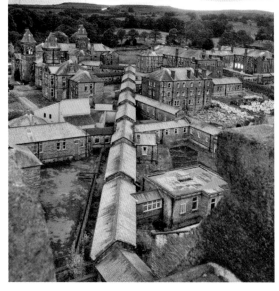

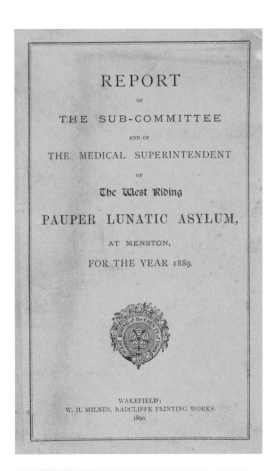

REPORT

OF

THE SUB-COMMITTEE

AND OF

THE MEDICAL SUPERINTENDENT

OF

The West Riding

PAUPER LUNATIC ASYLUM,

AT MENSTON,

FOR THE YEAR 1889.

WAKEFIELD:
W. H. MILNES, RADCLIFFE PRINTING WORKS.
1890.

Menston Asylum, *c.* 1889

Initially, when the asylum first opened, it consisted of the central administration building, flanked by wards to accommodate the sick and infirm, the recent and acute cases and the epileptics. Medical Superintendent Dr John Greig McDowall (former medical officer at Wadsley Asylum) was assisted by two assistant medical officers, Dr James Whitwell and Dr Turner. Like all the asylums the institution was to become in effect an isolated self-contained village for the insane. In time the hospital included a library, a butcher's, a cobbler's, an upholsterer's, four farms, a patient's bank and shop, a tailor's shop, and even its own railway linked to the main line. In the photograph below the clock tower can be seen with a red tiled belfry atop. The belfry housed a single bell that marked the hours day and night. Fred E. Rogers later recalled a patient who was firmly convinced that every time the bell tolled, an inmate was hanged at the Pumping Station. He would doff his cap, cross himself and mutter: 'Another one gone, poor soul!'

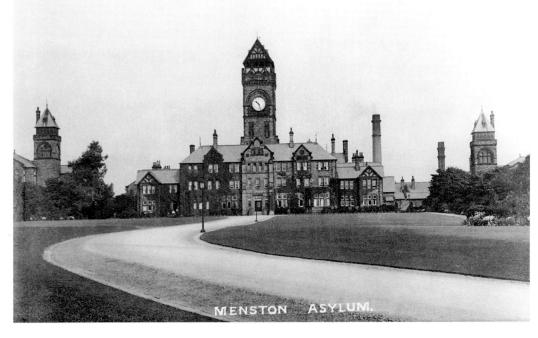

MENSTON ASYLUM.

Menston Asylum – the Mortuary

Unlike the other West Riding Asylums, which buried the asylum dead at the parish churchyard, it was decided to set aside a piece of land on the estate at Buckle Lane specifically for the patients who died at Menston, due to their remains not being collected by their families. The laying out of this area of land was completed in December 1890, which coincided with the mortuary becoming operational. As with the Wakefield Asylum, 90 per cent of patients who died were given post-mortems. In 1896, of the 1,501 patients in residence there was a 36 per cent recovery rate, while 187 died, the largest killer being 'General Paralysis of the Insane' (a diagnosis now believed to refer to neurosyphilis) claiming 59 lives. Recently the original mortuary table was kindly donated to the Stephen Beaumont Museum of Psychiatry at Wakefield, seen with Michael McCarthy, the former curator, in the later image.

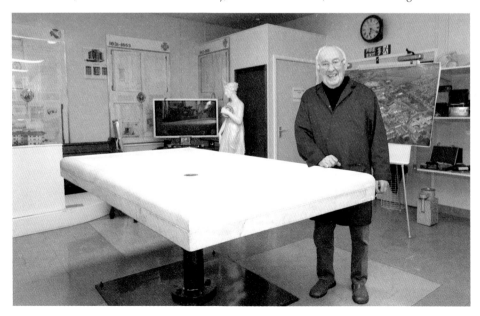

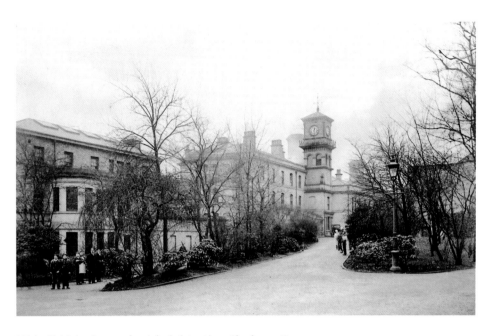

Wakefield Asylum – the Administration Block, *c*. 1892
Stepping back in time to 1892 we take in the main entrance to the asylum via the clock tower. The buildings around the clock tower were later additions to the original building and were occupied by the administration department, with the kitchens in the distance directly behind the tower. To the left of the image, male attendants supervise asylum patient staff including two teenage boys, while below the clock tower a hansom cab is reversed to the main door. In 2012, when comparing the two images of the long-closed former asylum, we see much has been demolished during the conversion to housing. The clock tower is now restored, which still helps to regulate the routine of the new occupants, albeit on a much more relaxed basis.

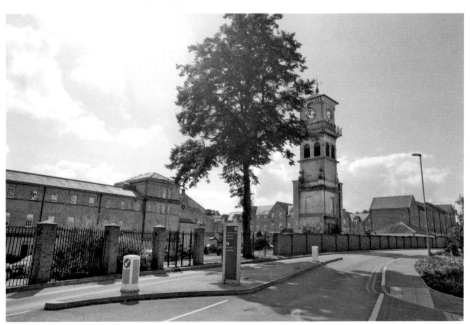

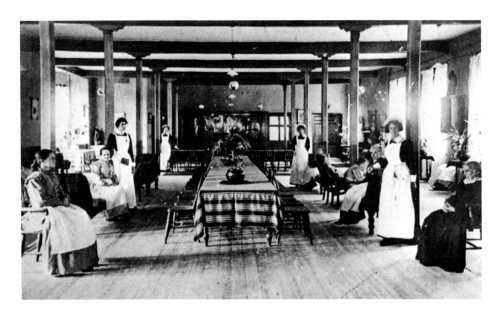

Wakefield Asylum – Female Day Room, *c.* 1898

Seen in the late 1890s is a typical ward dining room. A scattering of patients and nursing staff gives the impression that the ward is more than adequately staffed. In reality there would only be three or four day nurses supervising wards of seventy patients or more. An indication of the asylum being understaffed is seen above the table in the form of a mirror ball used throughout the hospital to observe patients, even from behind. The later image taken in the early 1960s depicts a similar ward having just undergone modernisation as part of an extensive programme of breathing new life into the old women's chronic block. In 2012 Stanley Church stands condemned and empty awaiting demolition. Somewhere in the graveyard there are hundreds, if not thousands, of patients buried in unmarked graves interred during the lifetime of the hospital. This page is dedicated to their memory.

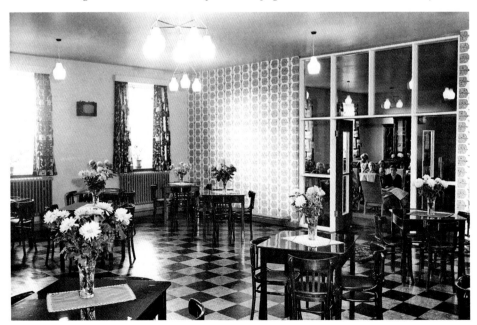

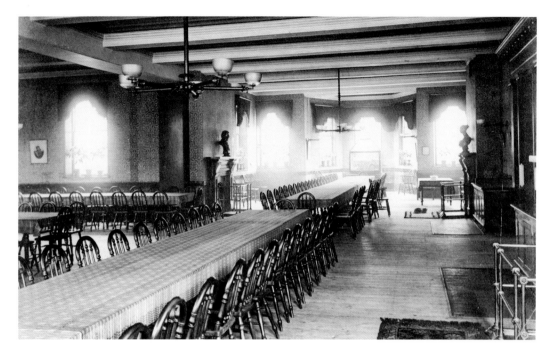

Wakefield Asylum – Netherfield, c. 1894
Pictured is the dining room of ward 20, later known as Netherfield. The ward was built in 1866 to house a maximum of 120 working male patients, with many of them employed in the gardens or laundry. Dominated by long tables and wooden chairs, the room also shows substantial locked fire guards (present in all wards) and some ornamentation, which at the time was deemed to be lacking in home comforts, especially in relation to the supply of books and contemporary magazines. When closure came in September 1995, Netherfield was demolished. The original location is now beneath the new Pinderfields Hospital.

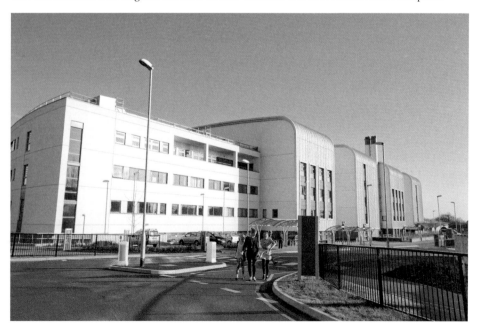

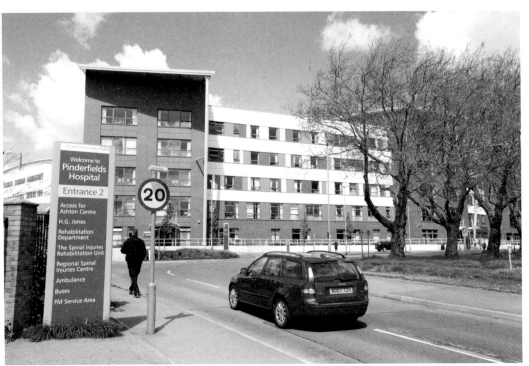

Wakefield Asylum –
Subterranean Reservoir

The underground reservoir was built in the late 1850s to collect spring and rainwater and served the laundry and boiler house for many years. Photographed in the 1950s, the reservoir with the repeated arches had ceased to be used just prior to the Second World War. During the demolition of the old asylum the reservoir was located opposite Netherfield Ward, spanning the road where traffic now passes in and out of the new Pinderfields Hospital. It is believed to still exist although this is not confirmed.

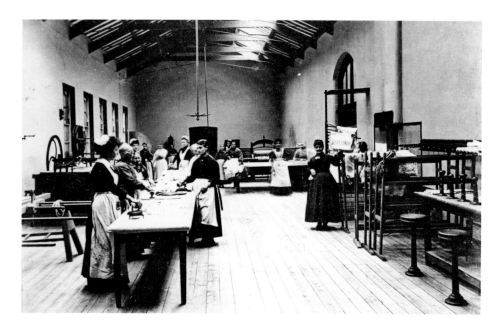

Wakefield Asylum – the Laundry, c. 1900

There was certainly a laundry department in operation from the early days, but it was not until 1849 before this purpose-built building shown in both images was constructed in the eastern extremity of the site. Six years later in 1856 a two-storey wing was added (known in later years as Garth House) to accommodate the sixty patients employed in the laundry, which functioned in this way for over a century. It was only in later years that the door linking the accommodation to the laundry was finally bricked up. The photographs taken in both the washroom and ironing department at the turn of the twentieth century show asylum staff and patients working in both departments, with the staff easily recognisable by their key chains. The site of the laundry like many other departments now lies under the new Pinderfields Hospital.

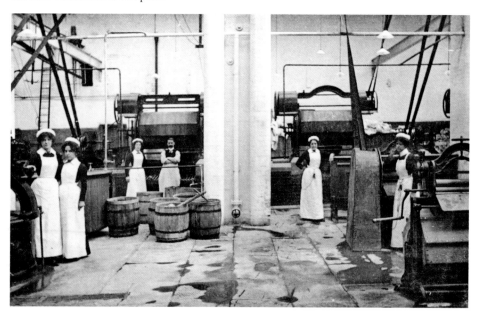

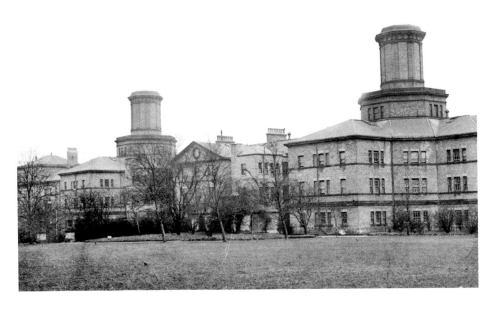

Wakefield Asylum – Female Chronic Block, c. 1900

Built as a near replica of the original 'H' block, the new chronic block for the long-term mentally ill was completed in 1848 under the directorship of Charles Corsellis. The earlier image taken at the turn of the twentieth century gives the impression of an almost prison-like building, which in fact it very much was. Certainly the wards were locked and people were incarcerated within the walls as a result of society's intolerance to their behaviour, even though it is now estimated that 30 per cent of all people sectioned in those days were unjustly incarcerated having committed no crime. The later image taken in the early 1960s after modernisation shows a typical dormitory where beds spaced very close together without bedside cabinets were standard practice.

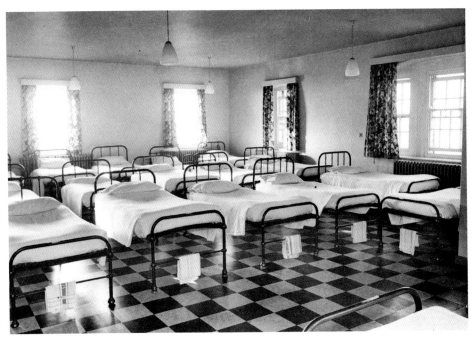

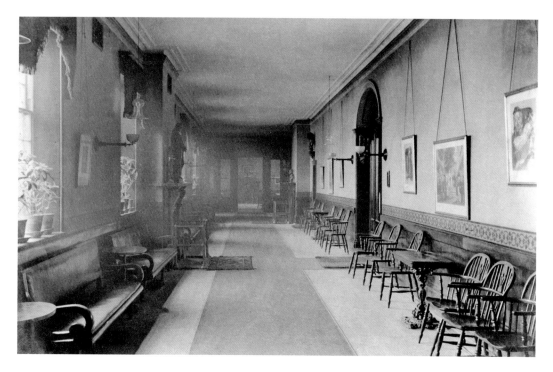

Wakefield Asylum – Tuke Ward, *c.* 1901

Clearly a male-dominated ward, the gallery was very much regimental with a lack of home comforts. The ward is part of the 1831 extension now converted into individual apartments. It was during 1901 that sixty-one attendants from all the West Riding Asylums petitioned the Wakefield Asylum Committee for a reduction of hours. In their petition it was stated the average working week took in ninety-five and a half hours. The committee, although believing the total hours per week being eighty-seven and a half hours, gave a small concession by reducing the average hours per week to seventy-nine and allowing an extra shilling per week to married attendants for lodgings.

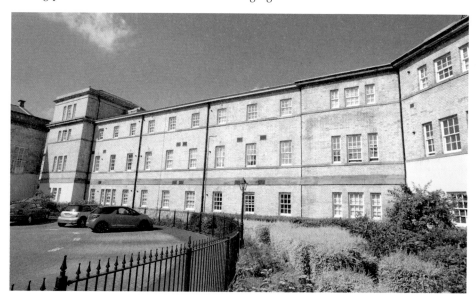

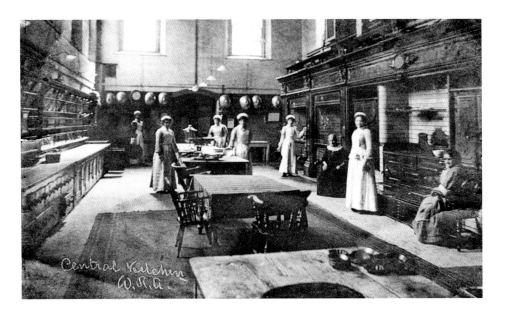

Wakefield Asylum – Central Kitchen, c. 1900

The central kitchen shown at the turn of the twentieth century. On the right are the coke-fired drawplate ovens, which were a feature until the 1950s when they were replaced with gas ovens and steamers as seen in the later image. In the early image the working patients are seated while the asylum kitchen staff stand for the late Victorian photographer. Regardless of position, be it seamstress, kitchen worker, or laundry assistant, staff would still be referred to as nurses. During the 1950s the meat and potato pies made in the kitchens became famous for being 'the best you would ever taste'. Such was the popularity with staff and patients the slope down to the kitchen became known as 'pie hill'.

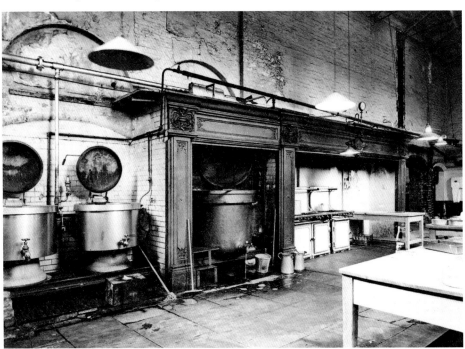

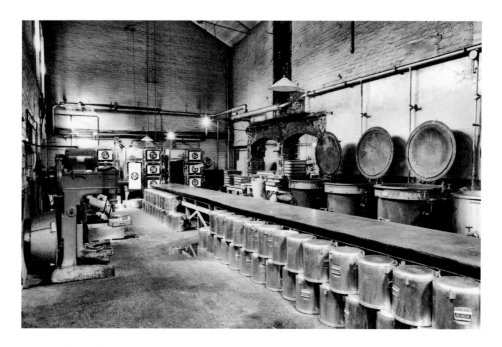

Wakefield Asylum – Central Kitchen, *c.* 1950

On 26 August 1984 there was a major outbreak of salmonella at Stanley Royd Hospital which directly caused or contributed to the deaths of nineteen patients. In total 355 patients and 106 members of staff were affected, the cause of which was attributed to contaminated chickens and cold beef brought into the old asylum kitchen. The former kitchen was demolished as part of the regeneration and conversion of the building; the original location was very close to the area of tarmac shown in the later image. This page is dedicated to the memory of all those who lost their lives as a result of the outbreak.

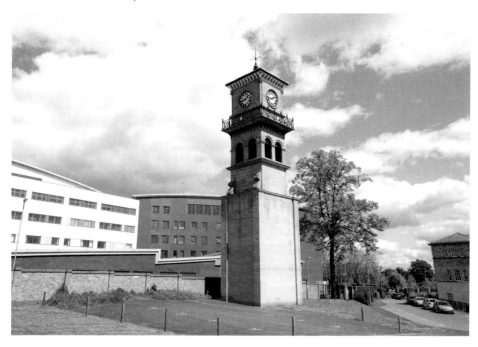

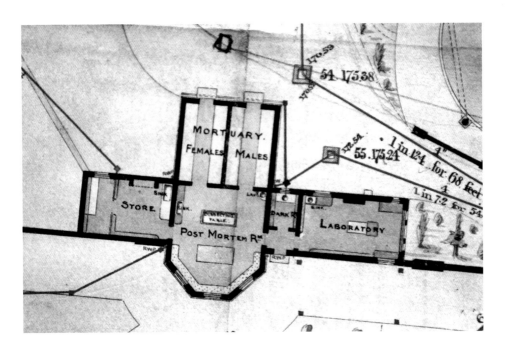

Wakefield Asylum – Mortuary, *c.* 1888

The plan of the mortuary, dated 1888, shows that strict segregation for the opposite sexes was carried out even after death. At the time the mortuary, which contained a dark room and laboratory, was regarded as an important source of research, especially when examining brain tissue for abnormalities. Post-mortem examinations were carried out on an average of 90 per cent of people who died in the asylum. The largest killer by a short margin was 'General Paralysis of the Insane' followed closely by senile decay and tuberculosis. The mortuary was later converted into a patients' library, as seen below in the 1950s photograph, before being utilised as a linen store.

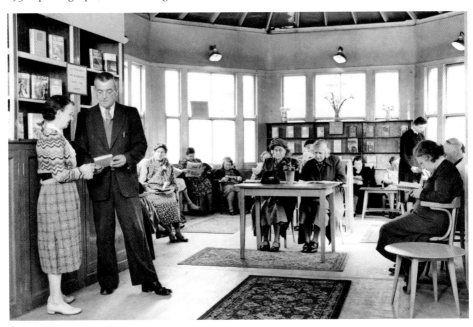

Scalebor Park – Burley in Wharfdale

Although the four joint West Riding Lunatic Asylums catered for the pauper insane it was not unknown for private patients to be resident. In effect if an individual had the means, they had to pay for their forced incarceration. Despite having to pay up to a pound a week conditions in the main were no different to the rate-aided patient. In 1898 the West Riding Council sanctioned the building of a private asylum to cater for these patients, offering far superior standards of comfort and care for a smaller population based on the original ideals of Dr Ellis of the Wakefield Asylum. Scalebor Park opened in 1902 and continued receiving private patients until 1948 when the advent of the National Health Service enabled beds to be available for all. Closed in 1995 the whole site has since undergone both conversion and regeneration to quality housing.

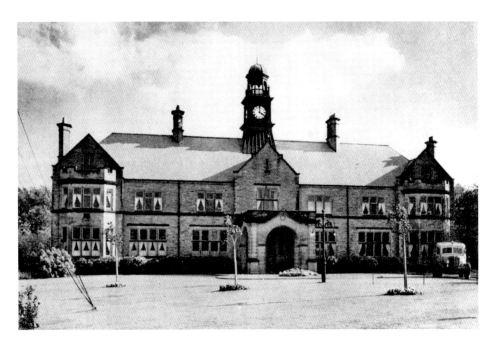

Storthes Hall Asylum – Kirkburton, Huddersfield, c. 1954

As the number of beds required in the West Riding increased at a rapid rate in 1897 the Asylums Committee had no option but to open the fourth West Riding Pauper Lunatic Asylum. In 1898, Storthes Hall, Huddersfield, and part of an estate covering 630 acres upon which the new asylum was to be built was purchased from Mr Thomas Norton. The new asylum, designed to a compact arrow design by J. Vickers Edwards, who had previously excelled himself drawing up the plans for the Menston Asylum, opened in 1904 with the first patients taking residence on 2 June. This once sprawling institution closed in 1991. With the bulk of the buildings now reduced to rubble, all that remains is the administration building in a derelict state and the former mortuary.

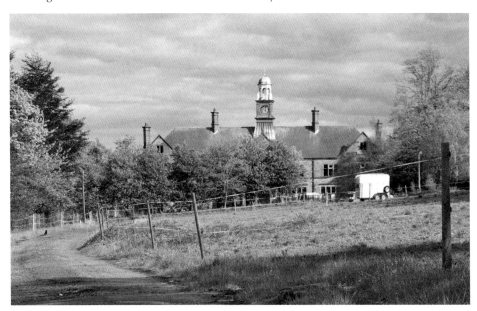

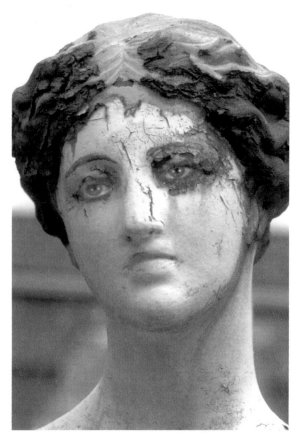

Wakefield Asylum – Statue of Flora

For many decades an attractive statue placed in the grounds of the hospital created a baffling mystery. Suggestions as to her identity inspired guesswork from patients and staff alike. Some said she represented St Dympnia to whom Catholics pray for pain relief from head injuries and mental illness. The mystery, however, was solved by Michael McCarthy, former curator of the Stephen Beaumont Museum, who lovingly restored her to her former glory. The statue, in fact, represents Flora, the Roman goddess of flowers and the season of spring. However, how she came to be in the hospital grounds looks likely to remain an unsolved mystery. When Michael resigned as curator earlier this year he had clocked up some twenty-eight years working for the health authority, having commenced working at Stanley Royd Hospital as a porter in 1984. Quite literally the very last employee of Stanley Royd, Micheal will be greatly missed by friends and visitors alike.

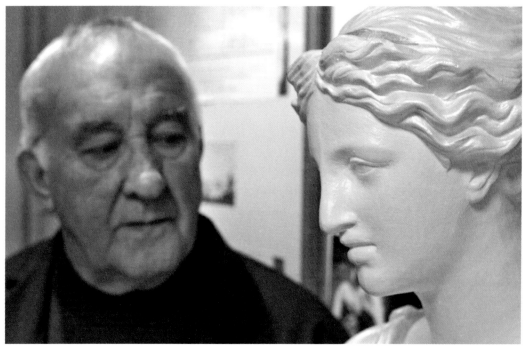

Menston Asylum – Tom Mellor

If conditions for the patient in the asylum were arduous at best, then the families left behind without a mother or father found themselves suffering too. Extreme poverty and hardship were common place, especially if the breadwinner was incarcerated. One particularly tragic case was that of Ada Beecroft, a young mother of two, who died in Menston Asylum in November 1899. Her common law husband Tom Mellor found himself left with two young stepdaughters aged four and five to bring up on his own. On the fateful night of 11 May 1900, having been turned away by his own sister when seeking assistance, he threw both little girls into the Leeds & Liverpool Canal in an apparent fit of despair. He was subsequently found guilty of the cowardly murder and executed by Billington at Armley Gaol on 16 August 1900.

DROWNING OF TWO LEEDS CHILDREN.

THE FATHER'S CONFESSION.

The Coroner for the city of Leeds (Mr. J. C. Malcolm) held an inquiry, at the Municipal Buildings yesterday, relative to the death of Ada and Annie Beecroft, aged 5 and 4 respectively, whose bodies were found in the Leeds and Liverpool Canal at Holbeck on Saturday morning last.

The father of the children, Tom Mellor, had been arrested on the charge of having murdered them, and he was in attendance in the custody of the police.

Mr. T. Thornton (from the Town Clerk's office), along with Superintendent Dalton, watched the case on behalf of the police.

The first witness called was Esther Anne Mellor, living at 13, Forest-street. She stated that her husband was the prisoner's brother. Formerly prisoner lived with a woman named Ada Beecroft. Besides the two deceased children, they had another child, but that died at the General Infirmary shortly after birth. The mother, Beecroft, died in Menston Asylum last November. Since then prisoner had taken charge of the children, and had

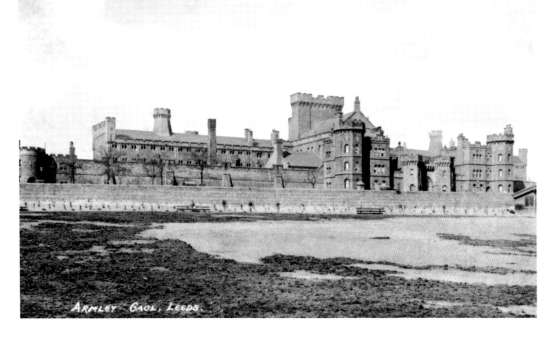

ARMLEY GAOL, LEEDS.

51

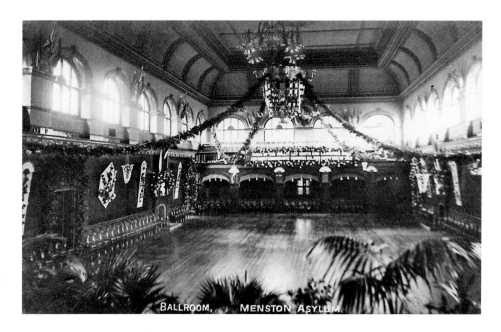

Menston Asylum – Ballroom, *c.* 1910

The annual patients' fancy dress ball held just after Christmas was the social event of the season with some 800 dancers taking part. Magnificent decorations took weeks to prepare and arrange, with brightly coloured festoons and tinsel draped overhead and along the walls. Each member of staff was given a ticket, which was not meant to be transferable, but people from outside would pay good money for them. The ladies had small printed programmes with a little pencil attached to their wrists and vied with each other for the best ballgown and the most dancing partners. The ballroom also doubled up as a church on Sundays until a prefabricated chapel was opened in 1967.

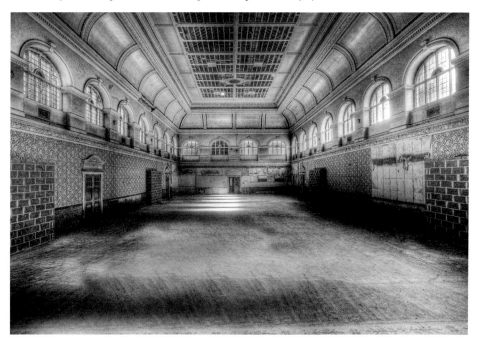

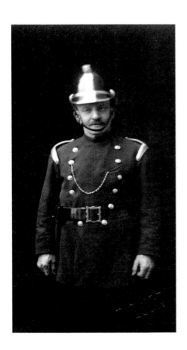

The Sub-Committee further reported—

Fire at Menston Asylum.

That on Sunday, the 15th January, 1905, an outbreak of fire occurred at the Menston Asylum, upon which the Medical Superintendent reported to the Sub-Committee at their Meeting on the 17th January last as follows :—

"I have to report that on Sunday, the 15th January, 1905, shortly "after noon, the fire alarm bell rang, the indicators showing that the "alarm came from the Epileptic block on the female side. On visiting "the Ward I found a slight crack in the ceiling near the top of the wall "through which flames were very readily seen."

"The Patients were at once removed to the new Female Block."

"The Nurses had already the hose pipes attached and on beginning to "play on the burning spot large pieces of plaster soon fell and shewed "that a serious fire was raging in the roof. Considerable difficulty was "experienced in getting at the fire from the shape of the roof. It was "soon evident that the felting in the roof was carrying it in all directions. "A large number of jets were soon playing on the roof both within and "without the building, and eventually, after the slates had been broken "through, it was seen that the fire was fairly well mastered. Before this "had been done however a very large portion of the timber of the roof "was destroyed, and it was necessary to remove a large number of slates "as the felt continued to re-ignite."

"The Fire Brigade from Otley arrived later and rendered valuable "assistance. Our own Fire Brigade worked admirably, two or three of ' the Attendants particularly distinguishing themselves."

Menston Asylum – Albert Edward Waite

All of the West Riding Asylums had their own fire brigades; the members made up in some cases were both staff and patients. Pictured is Albert Edward Waite, who was first employed at the age of eighteen in 1903, as an engineer with the additional role of firefighter. Thankfully not many fires broke out, but one of note occurred in January 1905 in the female epileptic block ward, later known as 'Litton'. In all 120 female patients were safely evacuated with no loss of life despite the fire causing considerable damage. By the time Albert retired in 1934 he had achieved the position of chief engineer like his father Isaac Waite, who had held the position before him, having retired in 1921.

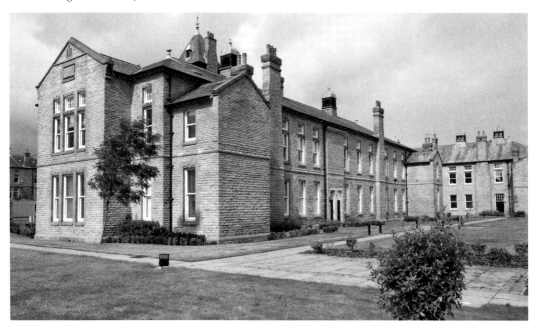

Menston Asylum –
Dr Samuel Edgerley

Medical Superintendent John Greig McDowall was assisted by Dr James R. Whitwell until 1897, when Whitwell resigned to become the Medical Superintendent of the Suffolk County Asylum.

Dr Whitwell's replacement was Dr Samuel Edgerley (pictured left) who had transferred from Wadsley Asylum. Dr Edgerley was in effect Deputy Superintendent until 21 November 1906, when Dr McDowall collapsed suddenly and died.

Dr McDowall left a young widow and a nine-year-old daughter, and his heavily attended funeral was held in the ballroom before his remains were transported back to his native Dunfermline in Scotland.

Dr Edgerley, a fellow Scotsman, was officially promoted to Medical Superintendent in December 1906; a position he held in high esteem until his retirement in 1933. His retirement party was held in the ballroom specially decorated for the occasion.

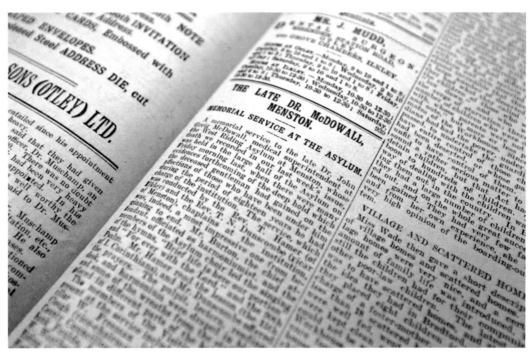

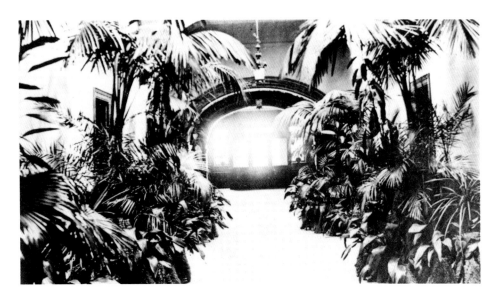

Menston Asylum – Central Corridor, c. 1910

The central corridor facing the main entrance was, according to Fred Eric Rogers when writing his memoirs of his time at the hospital, the Holy of Holies where only those with a bona-fide business were allowed to set foot. Rubber-soled shoes were the order of the day when walking this corridor, for making a noise would find the Medical Superintendent's door opening with the good doctor glaring at the culprit over his glasses. Seen in 1910 to the right through the foliage is the door containing the hall porter's twin rooms where he quite literally slept on the job. The porter, who cut an impressive figure dressed in frock coat with a cravat and an enormous tiepin, greeted all callers six days a week from 5.30 a.m. till 10.30 p.m. Bowing to the waist he would enquire, 'What is your business, sir, please?' The magnificent mosaic floor seen in the later image was laid as the hospital was built. Legend has it that Italian craftsmen employed when laying the tiles placed a tent around themselves, ensuring their craft remained a secret.

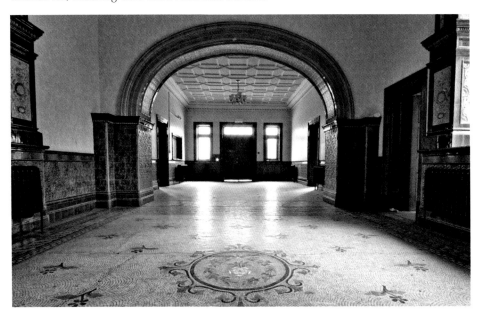

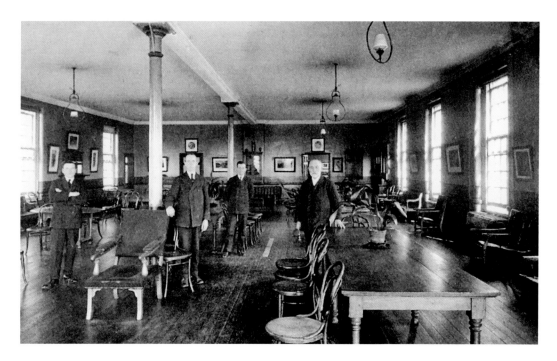

Menston Asylum – Chronic Blocks, c. 1910

As with all the West Riding Asylums expansion was always a part of daily life as demand for beds increased. The original building, although initially large enough, quickly proved inadequate, and two new blocks for the chronically ill were soon built, providing 300 beds for each sex when completed in 1895. The system of certification meant that usually admission was delayed until all hope of improvement was gone; to enter the asylum was in effect a life sentence of incarceration and patients transferred to these blocks were highly unlikely to ever be released. Pictured in 1910 is the day room of what would become Norwood and Burnsall, wards 12 and 13. This block was an additional male chronic ward added in 1909 after the 1895 additions had been filled to capacity. All that remains of this now-demolished ward is the signage.

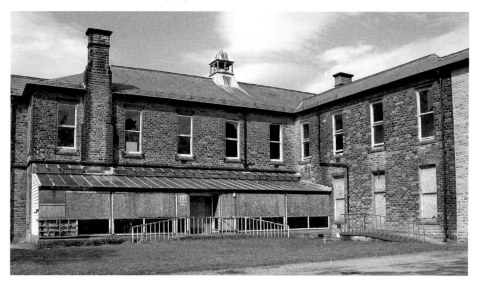

Wakefield Asylum – Dr Joseph Shaw Bolton, Medical Director, 1910–33

Dr Joseph Shaw Bolton was appointed Medical Director on 21 September 1910, drawn from a shortlist of six candidates. Dr Shaw Bolton held not only impressive academic qualifications, but also had a wealth of experience from previous appointments at Claybury and Rainhill asylums, having made his name as both a pathologist and histologist. During his term as Director he held what is believed to be the first chair as Professor of Psychiatry in this country at the medical school in Leeds. In 1928 he delivered the Presidential Address to the Royal Medico-Psychological Association at the 87th Annual Meeting held at what was by then the Wakefield Mental Hospital. His chosen subject was 'The Evolution of a Mental Hospital, Wakefield 1818–1928', which was later published. Retiring in November 1933, Professor Joseph Bolton Shaw died thirteen years later in November 1946.

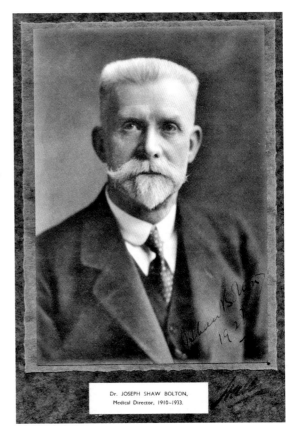

Dr. JOSEPH SHAW BOLTON,
Medical Director, 1910–1933.

The Royal Medico-Psychological Association.

ANNUAL MEETING, 1928.

PRESIDENTIAL ADDRESS

Delivered at the Eighty-seventh Annual Meeting of the Royal Medico-Psychological Association held at the West Riding Mental Hospital, Wakefield, July 11, 1928.

THE EVOLUTION OF A MENTAL HOSPITAL— WAKEFIELD, 1818-1928.

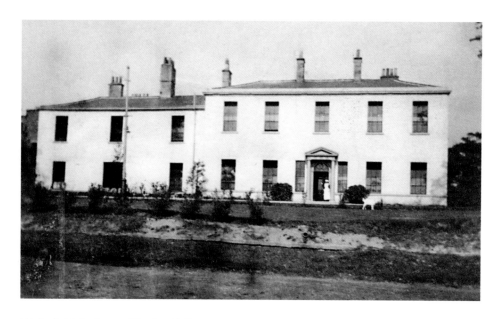

Wakefield Asylum – Stanley Hall

Stanley Hall was at one time the home of Thomas Wentworth, Lord Strafford, one of King Charles I's chief councillors, who was later deserted by the King and executed on 12 May 1641. His last words were, 'Put not your faith in princes.' The Wakefield Asylum Sub-Committee purchased the hall, which stands in 48 acres of agricultural land and gardens, in 1899 to provide accommodation for sixty male 'idiots' under the age of eighteen, as the board of visitors had noted many children housed in adult wards with what we would now term as learning difficulties. Dr Charles W. Ensor of Wakefield Asylum, assisted by a cook, housekeeper, schoolmistress, and six day and three night attendants, superintended the hall. Young boys were transferred from all the West Riding Asylums to the hall where conditions represented more of a boarding school than an asylum ward. The building in 2012 now serves as a nurses' home.

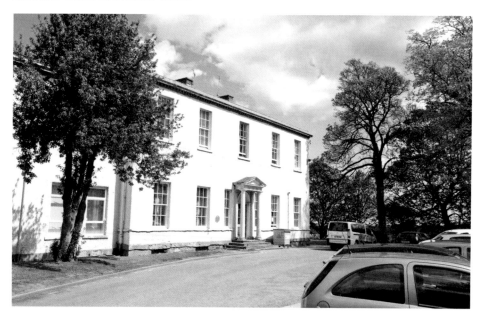

**Wakefield Asylum –
Stanley Hall, c. 1924**
Pictured below are a group
of patients in the grounds of
Stanley Hall, by then a Mental
Deficiency Colony. Many of the
boys were encouraged to take
part in farming activities, even
keeping their own pets. The
boy in the centre, called Arthur,
was taken under the wing of
Dr Joseph Shaw Bolton, who
allowed him to rear poultry at the
hospital commercially. Being both
enterprising and hard working
the venture was a huge success
and when a vacancy came in
the transport department he
went from patient to employee
– something totally unheard of in
the days when people classed as
mentally defective were normally
locked away indefinitely. Sadly
Arthur, who married a nurse
and even bought a house, died
at an early age from leukaemia.
Pictured right is Nurse Popplewell
in 1924 at Stanley Hall during
Arthur's time.

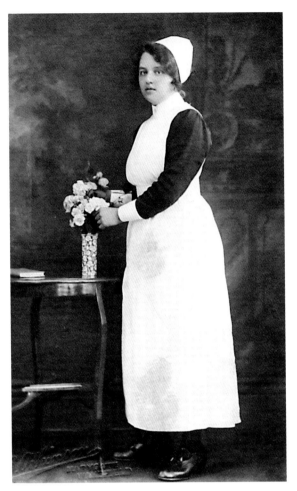

Wakefield Asylum – J. W. Mablethorpe, c. 1913

Shown in the image to the left are two junior male attendants in 1913. The young man on the right is J. W. Mablethorpe who was to become the chief male nurse of Wakefield Asylum. In the later photograph Mablethorpe is pictured with some of the evacuees from Dunkirk during the winter of 1940 on the drive to the acute hospital. The acute hospital, although still administered from the former Wakefield Asylum, had been taken over as an Emergency War Hospital for the war wounded.

Meanwood Park – the Mental Deficiency Act 1913

Quite often when talking about the old lunatic asylum, people have often referred to unmarried mothers being put away. The reality was really rather somewhat different. It is true that women were put in asylums having had children out of wedlock, but prior to 1913 there also had to be some form of mental breakdown, with the fact her sexual morals were in question having no official bearing on certification. With the advent of the Mental Deficiency Act people with learning difficulties were put into four different categories: idiots, imbeciles, the feeble minded, and the morally defective. Many people previously sent to the asylum were then sent to Mental Deficiency Colonies, such as Meanwood Park in Leeds, which opened in 1919. Once admitted there they were subject to what was, in effect, a life sentence. The act allowed the Workhouse Unions to send pregnant women out of wedlock to the colony under the label of 'feeble minded'. This was done not so much because they lacked intelligence, but more so because it was felt their sexual morals could only be attributed to a person not capable of protecting themselves. When Samuel Wormald, Executive Officer at Meanwood and member of the Eugenics Society, retired he proudly boasted of having taken over 2,000 people off the streets of Leeds.

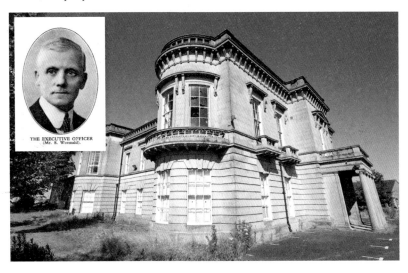

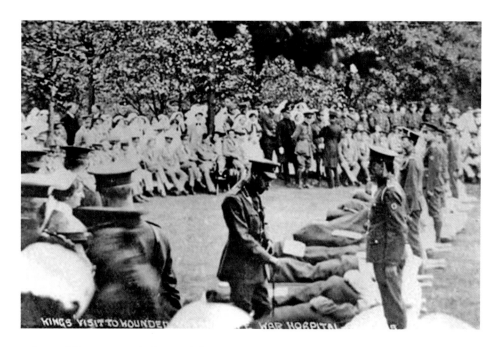

Wharncliffe War Hospital – Wadsley, c. 1915

When the First World War descended upon Europe, the Board of Control in 1915 announced that a scheme had been prepared to supply the War Office with 15,000 beds for the war wounded. It was proposed to divide the country into areas, with one asylum in each area to be used as a war hospital. Wadsley was selected in the West Riding. The evacuation of the mental patients was completed in just two weeks, distributed mostly between Wakefield, Menston, and Storthes Hall asylums. With the approval of the War Office, Wadsley Asylum then became the Wharncliffe War Hospital with 1,500 beds. The asylum staff remained and the doctors were given military ranks. King George V visited the hospital in September 1915, stopping by all the wards, talking to many patients and enquiring of their circumstances. When the military handed back the hospital in July 1920 it was estimated 35,000 patients had been cared for since April 1915.

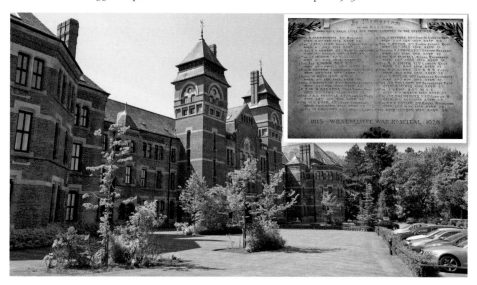

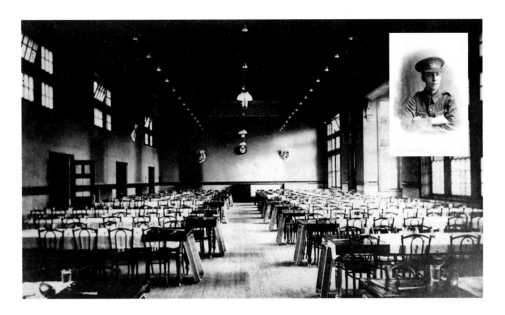

Menston Asylum – Charles Edward Teale

Charles, born in 1890, joined the staff of Menston Asylum after returning from the First World War having achieved the rank of Second Lieutenant. Initially employed as a male attendant (nurse) he worked on the male epileptic block, wards M5 and M6, later named Barden and Bolton, seen in the photograph below. In time he was promoted to charge nurse and also placed in control of the male dining room (pictured above around 1910). The dining room was located across the corridor from the ballroom stage. During the Second World War, Charles joined the Home Guard and captured a German parachutist. He disarmed him and marched his shaken prisoner to the cellar of the Ing's Hotel until the police took over. Charles retired in 1949. His daughter Mary and son Frank, following in his footsteps, also worked at the hospital, as did his brother-in-law, Fred Eric Rogers.

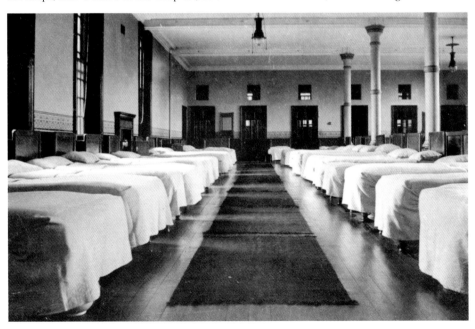

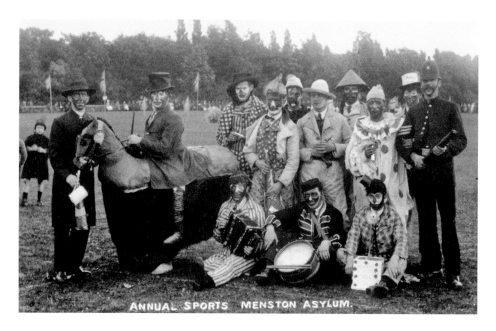

Menston Asylum – Annual Sports Day, *c.* 1914

In 1914, as Great Britain was plunged into the First World War, members of the asylum staff rushed to join the colours to bear arms in a fight that many confidently believed would end in victory by Christmas. However, by the conclusion of 1915, sixty-one members of staff from Menston Asylum had departed for active service, including two of the four assistant medical officers. It was surprising that activities such as the annual sports day still went ahead, especially when over 2,000 patients in residence were being cared for by what was virtually a skeleton staff. Such was the desperate situation in the asylum in 1916 that two male wards had to be put under the care of female nurses, the first time this had occurred in the history of the hospital. At the conclusion of hostilities in 1918, eleven members of staff had given their lives for their country, and a memorial to their ultimate sacrifice was erected in the central corridor.

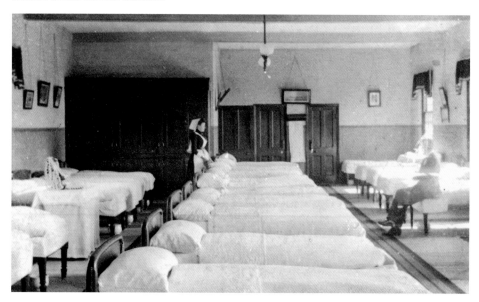

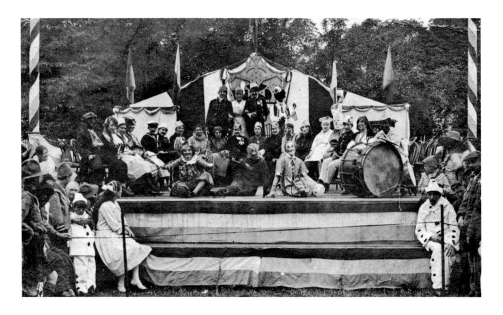

Wakefield Asylum – Armistice Day, *c. 1918*

The scene above depicts both patients and staff at Wakefield Asylum celebrating Armistice Day. The cease of hostilities occurred on 11 November 1918, just twelve days before the centenary of the asylum opening. Seated front centre is Medical Director Professor J. Bolton Shaw with Mrs Bolton and a member of staff dressed to represent Lord Kitchener. During the war many of the county asylums were accepting a new class of patient that was known as the 'service patient'. Casualties of the war included soldiers suffering from shell shock and other associated post-traumatic stress disorders; when returning from the trenches, the soldiers found themselves in a bed in the asylum instead of a hero's welcome. In 1920 Professor Bolton Shaw reported that there were some 122 former soldiers certifiably detained in Wakefield Asylum. The conditions of the 'service patient' differed from the pauper patient, by the additional allowance of 2/6d per week for special comforts and also the promise of not being buried in a pauper grave.

Belgian Refugee Lunatics.

That they have received a circular letter from the Local Government Board, in which that Board propose, with the concurrence of the Board of Control, that, as from the 1st July, 1918, the Lunacy Authorities should claim direct for maintenance of patients, from the Board; that the Lunatics should be classed as Private Patients, and that, as the position is not precisely that of an ordinary pauper lunatic received from a Union within the County, some slight extra charge might be made. The Board would, therefore, if desired, pay on the basis of the Out-County Rate.

Burial of Service Patients.

That they have received a communication from the Board of Control stating that the Minister of Pensions was of opinion that some special, and not elaborate arrangements should be made for the burial of Service Patients dying in Asylums, whose bodies were not removed by their friends for interment and that all such patients should invariably be buried either in the church yard of the Parish in which the Asylum is situate, or in the Local Cemetery, and not in the cemetery belonging to the Asylum, nor in any ground set apart for the burial of pauper patients dying in the Asylum.

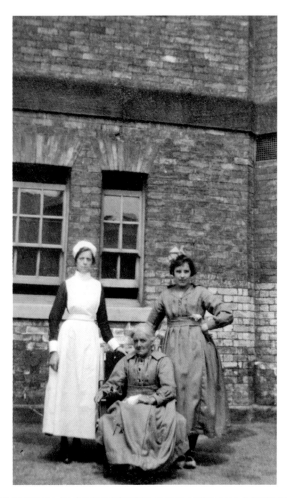

Wakefield Asylum – Sarah Tolson, c. 1920

Sarah Hannah Rose Tolson's nursing career at Wakefield Asylum commenced on 11 July 1919 aged just twenty-one. Her weekly wage as a probationer on trial was 32s a week, with an additional short-lived war bonus. Her contract of appointment clearly stated that if she were to marry, she would have to forfeit her position. Sarah devoted her whole working life to the hospital, never marrying, and she then retired aged fifty-five in May 1953. Shortly before retiring, she was offered the new pension scheme, which allowed a small lump sum with an index-linked annual allowance, which she accepted. Many of her friends lived to regret accepting the old pension scheme, which gave a larger first payment but with a fixed annual allowance. It was during Sarah's career at Wakefield that new legislation was introduced in 1930. The new Act gave provision for the voluntary reception of patients without certification whilst also disassociating the treatment of the mentally afflicted from the Poor Law. Pictured left is Sarah's friend Sarah Ellen, just outside the female chronic block in 1923.

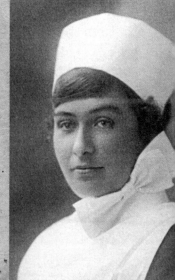

Serial No464......

This is to certify that..*Miss Sarah H.R. Tolson*

the holder of National Registration Card No:-

KNWI | 176 | 2

is employed at the Mental Hospital at Wakefield,

as..*Nurse*

Date..16 JUL 1940..Signed..*TW Hawkins*

~~Clerk and Steward~~

Signature of holder..*Sarah H.R. Tolson*

Address..*154 Church Lane Normanton*

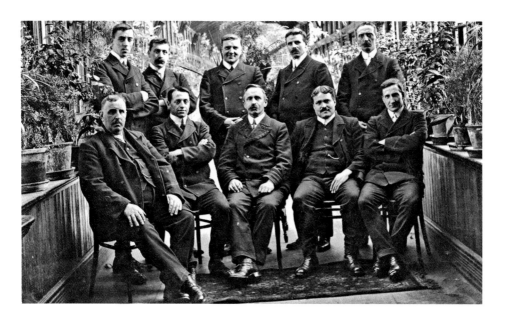

Menston Asylum – Nursing Staff, *c.* 1910

In the image above a group of Edwardian male attendants pose for the photographer in one of the corridors attached to the male wards. In general, nursing staff were employed based on their ability to read music, play a musical instrument or possess a good singing voice. Advertisements would appear regularly in the local newspapers, making it quite clear that previous experience was not important, preference being given to those with an extra talent that would benefit the asylum. For example, in 1898, when advertising for a shoemaker, the list of requirements for the applicant included a minimum height of 5 foot 8 inches as well as being able to play either the cello or the violin. The orchestra shown below include Chief Male Attendant Maude, who is stood to the far right on the back row. Male staff were largely drawn from the local population and quite often their sons and grandsons followed in the family tradition.

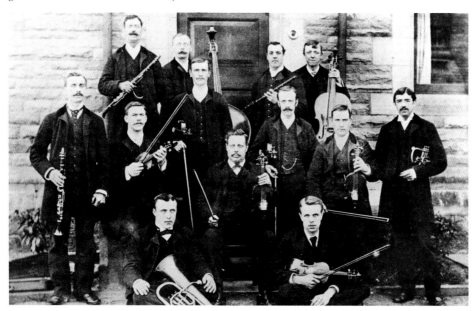

Menston Asylum – Dr R. Clive Walker, Medical Superintendent

Mr Robert Clive Walker was born in Edinburgh in November 1881. He was appointed the third superintendent on 1 January 1934 upon the retirement of Samuel Edgerely. He was the third Scotsman in succession to superintend the asylum. Dr Walker, the nephew of Dr Edgerely, originally commenced his employment at Menston on 20 May 1907. Clive, as he preferred to be called, married an asylum nurse, Dolly Green, in June 1921, with whom he had four children. The couple suffered a terrible tragedy in the 1920s when their young son David Johnstone fell to his death from a bedroom window of their house. When he retired in May 1947 aged sixty-six, the family intended to move back to Scotland. However, tragedy struck once again when his nineteen-year-old daughter Rosemary died three months later. Dr Walker passed away in 1975 aged ninety-three and his grave can be found by the side of Samuel Edgerley's in Menston Cemetery.

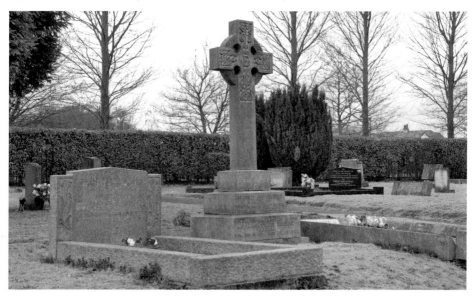

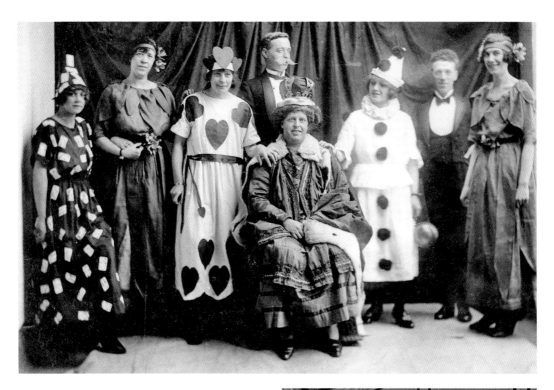

The Menston Players

The Menston Players were a stage company made up of asylum staff who put on various contemporary plays twice yearly between 1921 and 1935. The plays were directed and produced by Dr Kirwan (senior medical assistant) and were both lavish and professional and made full use of the stage within the ballroom/recreation hall. Clever acting and excellent lighting ensured the productions were hugely popular with both staff and patients alike. Such was the popularity that the company received rave reviews in the local newspapers year after year. Dr Walker appeared in many of the plays such as *Beauty and the Barge* during which his romance with nurse Dolly Green blossomed. In 1932 'Talkie' machines were installed in all of the hospitals' recreation halls replacing the old silent film machinery. Messrs Thomas Harrison Ltd of Bradford supplied the new Kalee projectors. To the right the magnificent stage area still exists to this day. Who knows what the future holds? Maybe one day the ballroom will once again resound to a healthy applause from an appreciative audience.

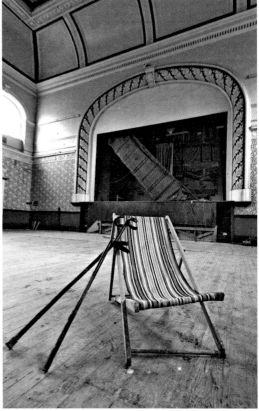

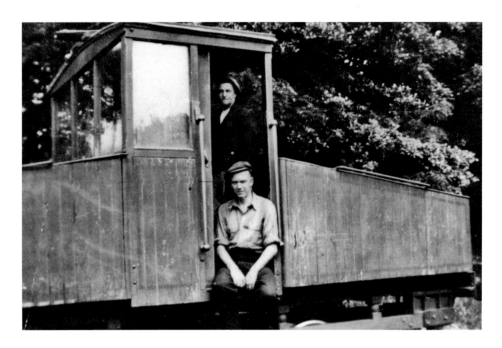

Menston Asylum – Railway, c. 1926

In 1897 it was decided to utilise the single-track line previously laid when the asylum was constructed by means of electric traction. Messrs John Fowler & Company provided the electric train, overhead wires and gearing, whilst a West Riding surveyor was employed to erect an engine shed and make any necessary repairs to the line linked to the Midland Railway. Pictured above is the later 30-hp English electric train purchased in 1924 when the older one had become inefficient. By the mid-1930s the majority of supplies were being delivered by road and the line, by now in need of repair, was mothballed, only to be reopened in 1939 when fuel became scarce. The line eventually closed in 1951, when it was dismantled and sold for scrap. Shown below is the bridge where the train once travelled under the Bradford Road in 2008 just prior to being filled in.

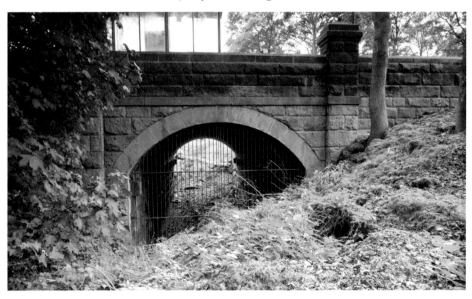

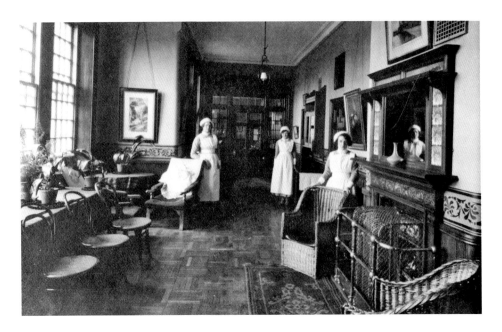

Menston Asylum – Isabelle Duesbury

Isabelle Duesbury was originally from the East Riding of Yorkshire and moved to Ilkley as a young woman before joining the staff at the asylum in the early 1900s. The image above with Isabelle stood on the far left was taken in the gallery of ward 15, the female sick and infirm block. The photograph gives the impression of a comfortable retreat, rather than a lunatic asylum. There can be no doubt that the scene, devoid of all patients, was staged to give that impression, the reality being somewhat very different. Isabelle is again pictured here below with her charges. Some of these women would have been put into the asylum quite simply as a result of going through menopause. In March 1927, during the time that Isabelle worked at the institution, hours were finally reduced to a more sensible forty-eight-hour week, a reduction of eight hours on the previous 1922 ruling. Years later Isabelle's grandson Ken followed in her footsteps and joined the staff at the hospital.

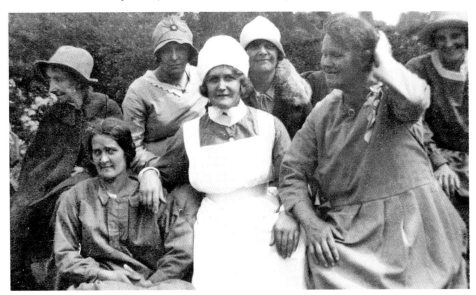

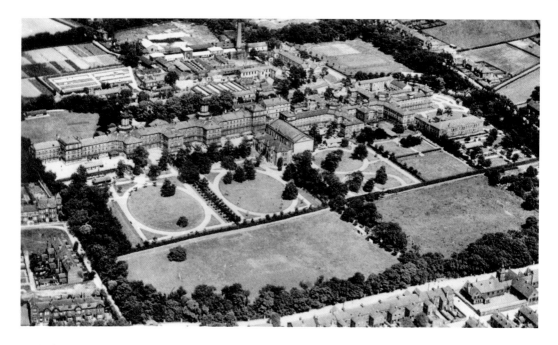

Wakefield Asylum, *c.* 1930

Photographed a century after William Ellis had departed to Hanwell, the asylum had evolved into a large estate equipped with every department required in a modern mental institution. The unsavoury term of 'Pauper Lunatic Asylum' had been dropped by the early 1920s and the institution was renamed Wakefield Mental Hospital. In the later image the regeneration shows all that was to be retained with the exception of the ballroom and chapel. In 2012 the site is now a large residential housing estate, which includes new homes and apartments, with the streets being named after former members of staff and people associated with the long history of this historic hospital.

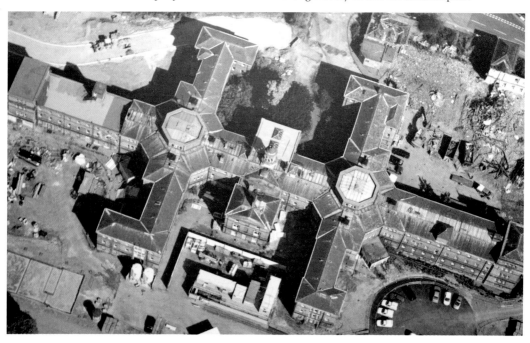

Menston Asylum – Fred Eric Rogers

When Fred Eric Rogers retired as the works storekeeper in 1971, he had nearly half a century of memories under his belt. He had witnessed the hospital evolve from Menston Asylum to Menston Mental Hospital, before eventually becoming High Royds Psychiatric Hospital. Fred was initially employed as an office boy and his duties included fire lighting, floor sweeping and brass cleaning, all for 10s a week. Writing his memoirs for the High Royds staff magazine *Contact* in 1971, he described the conditions in the 1920s: 'The wards were dark, being painted in bottle green or chocolate brown, with bare wooden floors or at best brown linoleum. The furniture was heavy and designed to resist damage rather than to provide comfort; there were no curtains on the windows, just blinds for privacy.' Fred is pictured on the back row to the left with the hospital choir; he was an active member for many years along with his niece, nurse Mary Teale. Below is the works yard where Fred worked.

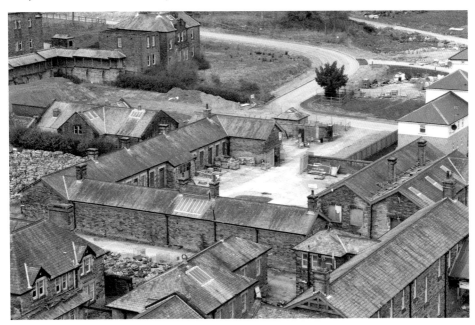

Lawrence dies after a life of dedication

A DEDICATED NHS employee, who spent 72 years of his life helping the people of Wakefield has died, at the age of 88.

Lawrence Ashworth, a writer and expert on the city's Stanley Royd Hospital, died after a short illness in hospital this week.

Mr Ashworth began his NHS career as a junior clerk in the treasurer's department at Stanley Royd Hospital in 1929.

By 1962 he had progressed to hospital secretary, but he will perhaps be remembered most for his work at the Stephen G Beaumont Museum – a museum about the history of the Stanley Royd Hospital, mental illness and patient treatment.

Mr Ashworth worked at the museum right up until he died and spent his time there sharing his mine of knowledge and experience about the hospital with visitors and school groups.

He also published two books and an academic paper about Stanley Royd.

Mr Ashworth, of Walton, Wakefield, leaves two daughters, Maureen and Joy, a granddaughter and a great granddaughter.

DEDICATED to the health service – Lawrence Ashworth, who died recently.

Wakefield Mental Hospital – Lawrence Ashworth

Lawrence Ashworth began his career at Wakefield Mental Hospital in October 1929 as a junior clerk in the treasurer's department when he was aged just sixteen. In 1962 just after the hospital had become Stanley Royd he had progressed to the position of hospital secretary. Although he retired in 1973 he continued his work with the hospital, assembling the Stephen Beaumont Museum, which chronicled the history of psychiatric care in Wakefield since the asylum opened in 1818. Lawrence was presented with a special award in recognition of more than seventy years service just a year before his death in 2001. In 2012 Lawrence was further honoured on the site of the old 1848 chronic block, the new Ashworth Square being named after him.

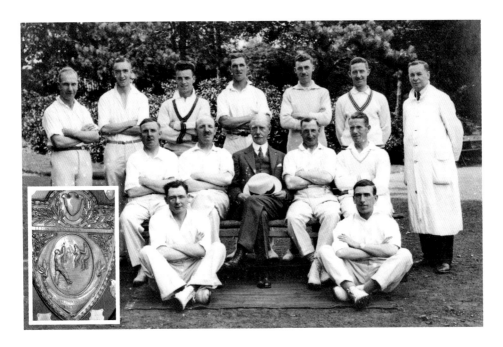

Menston Mental Hospital – Sporting Teams, c. 1924

Sporting events were an important aspect of hospital life and were also very competitive. Hospital teams would visit other hospitals competing for inter-hospital awards and trophies, making a welcome break from hospital routine. Pictured above is the Menston Hospital cricket team in 1924; Dr Edgerley, the medical superintendent, is seen with his hat across his lap. Although the hospital closed in 2003, the cricket ground is still used today by a local cricket team. Dr Edgerely is seen once again below with the hospital amateur football club in 1927. Clearly a winning year for the team and their trophy is proudly displayed.

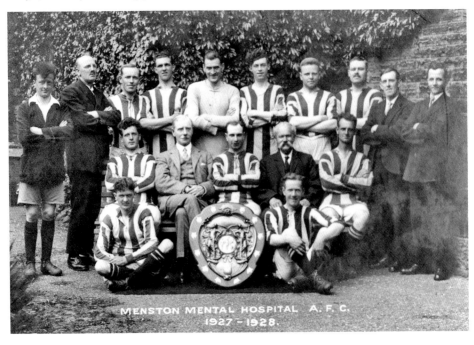

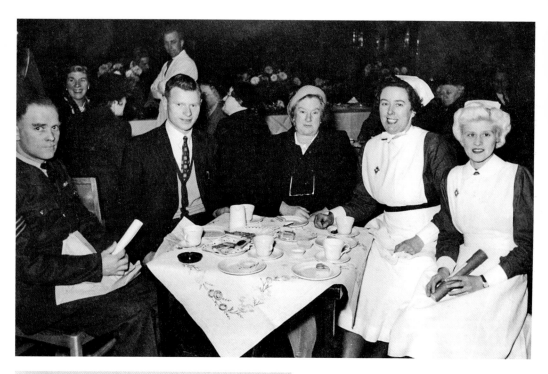

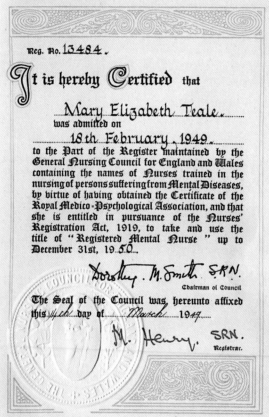

Reg. No. 13484.

It is hereby Certified that

Mary Elizabeth Teale.
was admitted on

18th February 1949.

to the Part of the Register maintained by the General Nursing Council for England and Wales containing the names of Nurses trained in the nursing of persons suffering from Mental Diseases, by virtue of having obtained the Certificate of the Royal Medico-Psychological Association, and that she is entitled in pursuance of the Nurses' Registration Act, 1919, to take and use the title of "Registered Mental Nurse" up to December 31st, 19.50.

Dorothy. M. Smith SRN.
Chairman of Council

The Seal of the Council was hereunto affixed this 14th day of March 1949.

M. Henry. SRN.
Registrar.

Menston Mental Hospital – Mary Teale

Mary Elizabeth Teale was born in 1919 and joined the staff just before the start of the Second World War in 1939 when there was a great deal of unemployment. As a child she had been brought up in that atmosphere and her father was Charles Edward Teale, as previously mentioned. Little did Mary know that she would be spending the next thirty-five years working at the hospital and remained single. Mary, pictured second from the right, recalled her times at the hospital in 1974 for the hospital magazine *Contact*: 'we had one lecture in duty time and one in our off duty and our other method of study was the "Red Handbook" recommended by the Royal Medico – Psychological Association, for whose certificate we were studying.' Mary passed her exam in 1949, gaining the title of registered mental nurse.

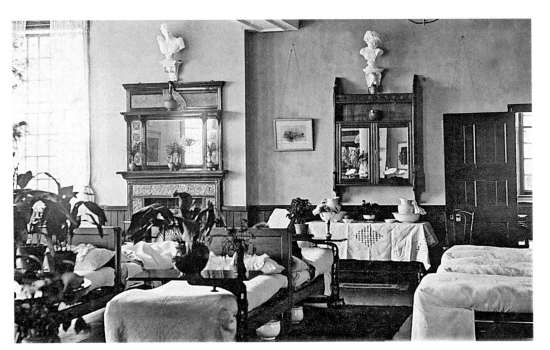

Menston Asylum – Ward 15, c. 1910
When the asylum first opened the first female admissions were settled into wards 15 and 16, which were later renamed Aysgarth and Hawes. Ward 15, photographed in 1910, compares favourably with the more spartan male wards seen previously. Mary Teale spent many years working on this ward. Describing conditions she recalled: 'All the ward work was all done by the patients, apart from wall washing and window cleaning, which the staff did, as patients were not allowed to climb steps. The uniform was grey with long sleeves, stiff collars and cuffs, and caps were gathered at the back with a tacking thread, to individual taste. The Charge Nurse wore "strings" and white belts and after passing the intermediate examination you could wear a grey belt.' The pavilion in 2012 has undergone an award-winning sympathetic conversion into quality housing, a credit to Ben Bailey Homes.

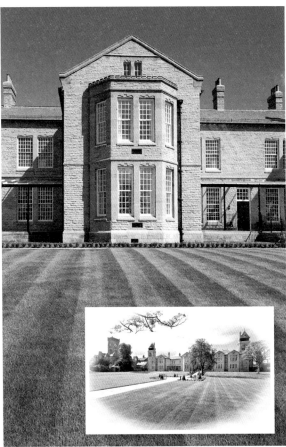

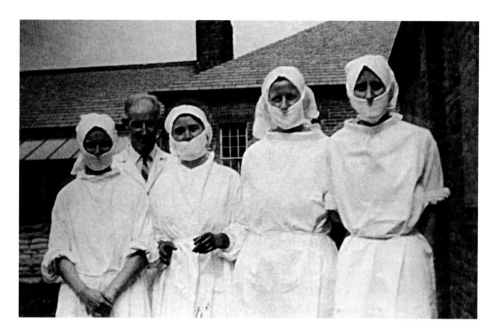

High Royds Emergency Hospital, *c.* 1942

As the war clouds once again hovered over Europe, plans were set in motion for the acceptance of the war wounded. Menston Mental Hospital gave up various wards, including Norwood and Burnsall to the War Office. Although the bulk of the hospital remained Menston Mental Hospital, the War Office called the requisitioned buildings High Royds Emergency Hospital. The first convoy of 218 soldiers from France arrived on 10 April 1940. The evacuation of the wards for the War Office caused major overcrowding within the rest of the hospital, resulting in the population peaking at nearly 2,500 patients in 1942 with constant staff shortages. For many years locals remembered seeing the military patients in their distinctive blue suits when visiting town. In 1945 the hospital war memorial was updated with the names of three more staff members.

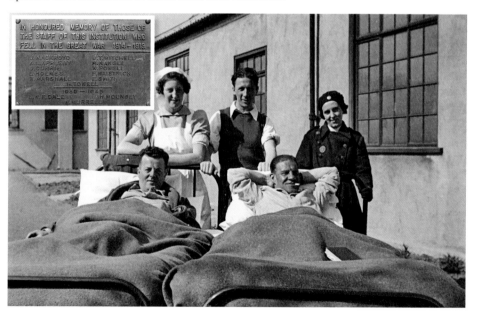

Pinderfields Emergency Hospital, c. 1943

Just as the War Office requisitioned the buildings at Menston, so was the acute hospital at Wakefield Mental Hospital. Named Pinderfields Emergency Hospital, the facilities catered for soldiers who had quite literally lost the will to live. Many of the men, with injuries such as broken spines and missing limbs, were put through gruelling rehabilitation programmes. Such was the success of the treatments in getting the men back on their feet that the *Picture Post* featured the hospital in May 1943, placing the emphasis on exercise to arrest muscle wastage. After the war the old acute became Pinderfields General Hospital.

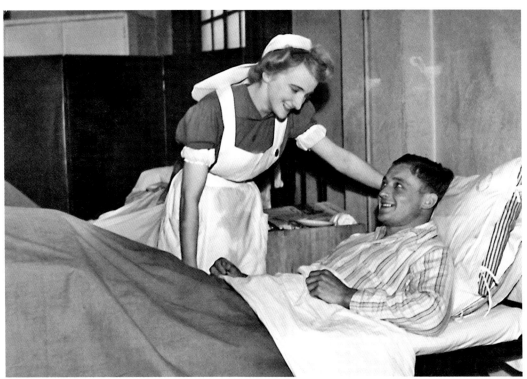

Menston Mental Hospital, *c.* 1949

In July 1948 as a result of the 1946 National Health Service Act, mental health became part of a comprehensive health service for the whole country. The West Riding Mental Health Boards were dissolved and Menston Hospital, like the other former asylums, was administered by its own Hospital Management Committee. As these changes were taking place, so were the new innovations in treatment. Electroconvulsive therapy (ECT), which had replaced convulsant therapy during the war, became more widespread. The post-war years also saw psychosurgery and insulin therapy play a bigger part in hospital life. The cleverly staged photograph above, taken in 1949, has Norman Hancock, the Chief Male Nurse, pictured front left, walking down the hospital drive with the visiting committee and Medical Superintendent Isaac Sutton, second from right.

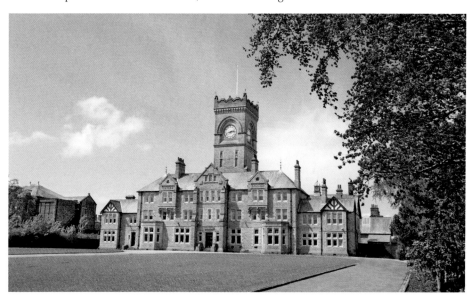

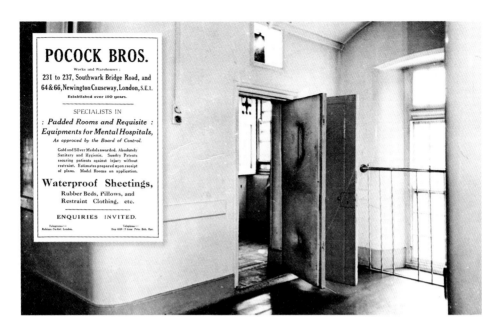

The advertisement within the image reads:

POCOCK BROS.

Works and Warehouses :

231 to 237, Southwark Bridge Road, and
64 & 66, Newington Causeway, London, S.E.1.

Established over 100 years.

SPECIALISTS IN

: *Padded Rooms and Requisite* :
Equipments for Mental Hospitals,

As approved by the Board of Control.

Gold and Silver Medals awarded. Absolutely
Sanitary and Hygienic. Sundry Patents
securing patients against injury without
restraint. Estimates prepared upon receipt
of plans. Model Rooms on application.

Waterproof Sheetings,

Rubber Beds, Pillows, and
Restraint Clothing, etc.

ENQUIRIES INVITED.

Wakefield Mental Hospital – Padded Cell, *c.* 1959

The padded cell has always been synonymous with psychiatric hospitals worldwide. The cell pictured was last used at Wakefield in 1959 when the widespread use of drugs had rendered this form of seclusion outdated and unnecessary. Although often seen as a punishment and a means of control, the cell was also used for epileptic patients as a means of protecting them whilst going through a fit. Padded cells were quite simply single rooms with padded panels and floor with a strong door hidden by an outer door. Repairs to the padded panels were carried out in-house in the upholsterer's shop. All instances of patients being placed in the padded cell had to be recorded to prevent improper seclusion.

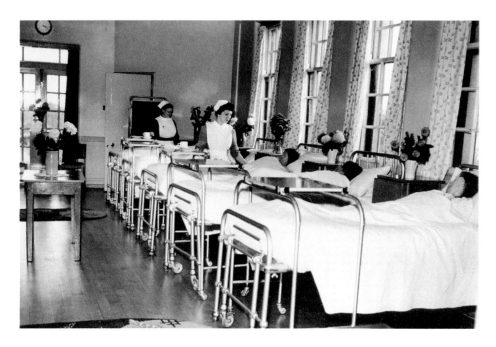

Menston Mental Hospital – Admission Hospital, *c.* 1962

The Admission Hospital was a purpose-built, detached, self-contained unit for the treatment of all the newly admitted patients of both sexes when it opened in July 1939. Pictured in 1962 is the female admission unit ward 33; the men were accommodated in ward 32. When all the hospital wards were renamed in January 1963 each ward was given the name of a village in the Dales, the Admission Hospital being named Escroft Clinic. It was during the 1960s that the concept of a hospital therapeutic community replaced the former custodial (safety first) ward management. Previously locked wards were opened giving the patients of both sexes a greater freedom to organise their own mixed social activities. The site of the demolished Escroft Clinic is now home to the new Glade Development.

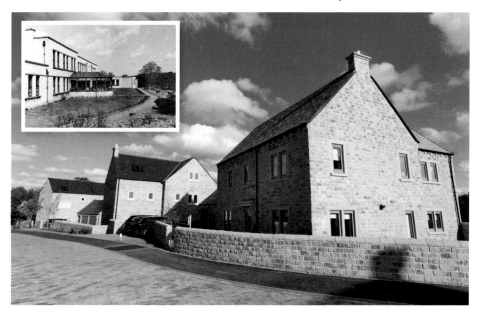

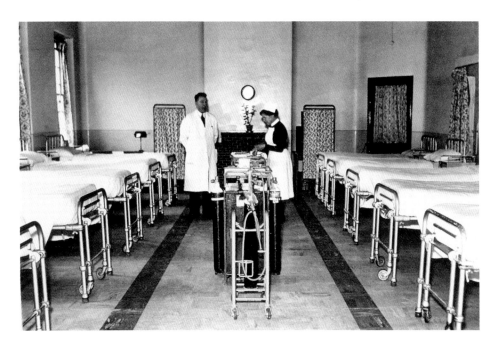

Menston Mental Hospital – Ward 22, c. 1962

Originally built as an isolation hospital and later renamed Kingsdale House, the treatment ward is seen above in 1962. The treatment of mental disorders had come a long way during the post-war years. The decade of the 'drug revolution' started in 1954 with the introduction of chlorpromazine (Largactil), which replaced the hazardous insulin shock therapy for schizophrenia. Running alongside with the anti-schizophrenic drugs came the discovery of a group of anti-depressant preparations, which received clinical trials in 1956. Although these new drugs were seen as an alternative to ECT in depressive cases electric shock therapy continued to be administered. Kingsdale House eventually became a geriatric ward prior to closure.

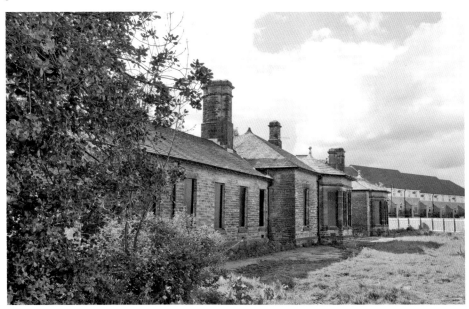

Stanley Royd Hospital – Enoch Powell, *c.* 1963

Pictured on the steps at Pinderfields is the Right Honorable Enoch Powell, on the occasion of his visit to Stanley Royd Hospital in September 1963. To the far right is Dr Peter Findlay Fletcher, Physician Superintendent 1954–74. Just two years prior to this photograph being taken, Enoch Powell, the then Health Minister, made his famous 'Water-Tower' speech at the National Association for Mental Health Annual Conference (now named Mind). His words, 'There they stand, isolated, majestic, imperious, brooded over by the gigantic water-tower and chimney combined, rising unmistakable and daunting out of the countryside,' were the first tentative steps in bringing about the dismantling of these vast old institutions. In 2012, like many of the country's former asylums, Pinderfields has been reduced to virtual rubble.

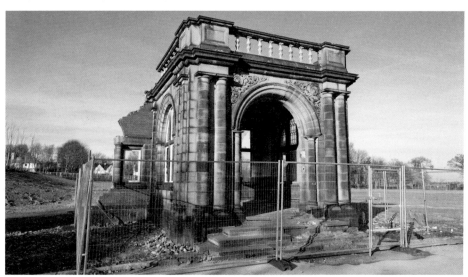

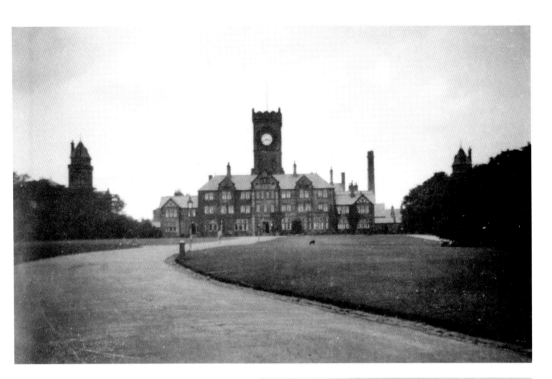

Martin Smith – 'Bring Out Your Deaf'

Martin Smith was employed by the Deaf Society as a missionary to provide support for the deaf. First visiting High Royds in 1957, he quite literally asked hospital staff to bring out their deaf. He quickly realised that many of the patients were suffering from nothing more than an inability to communicate. From then on Martin dedicated his life to the identification and resettlement of many unfortunate individuals who had been unjustly confined to life in secure mental institutions. One such person had spent fourteen years at High Royds before Martin secured his release, whereupon he was employed at the Deaf Club in Leeds as a caretaker. Martin believes that everyone has the right to hope; he rebuffed the system that took away a person's basic right to freedom. Martin launched his fascinating book *The Vanishing Missioner* in 2011, in which he tracks the early socialisation process that he went through in order to become a Missioner/Superintendent/ Welfare Officer.

High Royds Hospital, Denton Clifton, _c._ 1965

Although all of the Victorian pavilions are distinctive with their fairy-tale towers, Beamsley, Langbar, Denton and Clifton, former wards 1, 2, 7 and 14 respectively, differ by their missing towers. In 1948 a fire in male ward 7 had rendered repair of the tower uneconomical and it was demolished soon after. In 1965 modernisation of the block saw the second tower removed and the frontage updated. Prior to closure Langbar served as a 'Psychiatric Intensive Care Unit', which was along with the other wards was later used as a filmset for the series _Bodies_, focusing on a fictional special care maternity unit. In 2012 the former male sick and infirm block awaits imminent conversion.

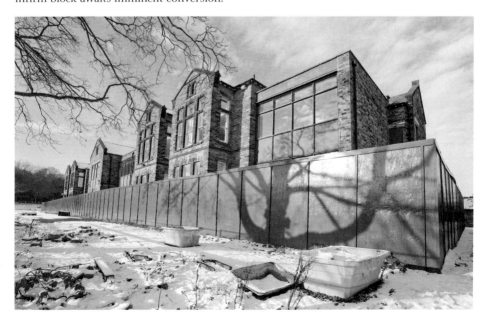

High Royds Hospital – Social Club, *c.* 1971

The High Royds Sports and Social Club opened in 1971 for the benefit of hospital staff, their friends and family. Originally the club was located on Laundry Drive but when the redevelopment of the hospital began after closure the club lived on, although now relocated in the former ward 10 (later Lindley), which was originally one of the 1895 male chronic wards. In time a brand new purpose-built club will be built in the grounds, but until then Heather, Tom and Bob continue to run the club using a winning formula of good quality food and drink at affordable prices. New members are welcome at the club where presently there is a photographic exhibition reflecting on High Royds.

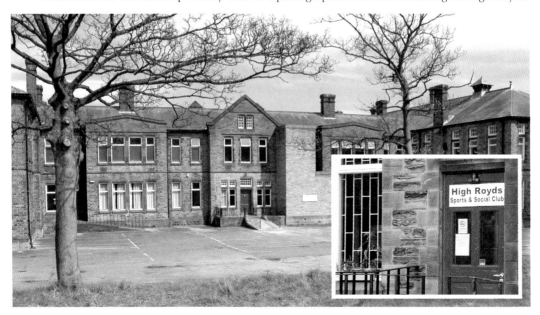

High Royds Hospital Committee, *c.* 1974

Pictured above is the Hospital Committee outside the clock tower in 1974. Braham Myers, seen middle centre, was appointed as a lay member to the then Menston Hospital Management Committee in February 1961. At that time the committee was chaired by a formidable lady, Alderman Mrs Hammond. She and the secretary, Mr Wheeler, were dedicated to the hospital and did their utmost to improve its services and funding. There were, however, over 2,000 patients and wards of eighty beds were fairly common. The name of the hospital was changed by a committee vote to High Royds in 1963 and the title of Dr McDonald, the Physician Superintendent, was altered to Medical Director. In 1974 changes in the NHS structure meant the end of the management committee. Braham, now in his ninety-first year, recently attended the memorial service at Buckle Lane with his wife and daughter.

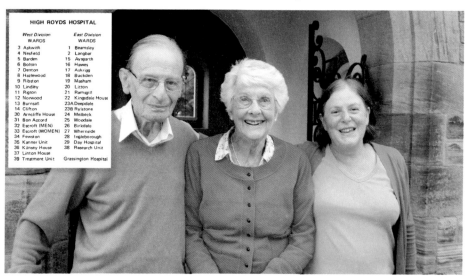

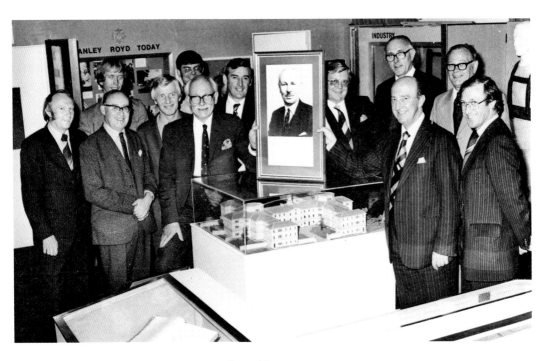

The Stephen Beaumont Museum of Psychiatry, c. 1979

Pictured here in September 1979, Stephen G. Beaumont and senior staff from Stanley Royd Hospital are at the naming ceremony for the museum. Originally located in the old building when the hospital closed in 1995, the museum was moved to Fieldhead Hospital in Ouchthorpe Lane. The museum is dedicated to charting the long history of the former asylum during its 177 years of providing care and treatment. A must for all those interested in exploring the history of mental health treatment, the museum contains a host of historic items including restraining equipment, a padded cell, a mortuary table and medical and surgical equipment documents.

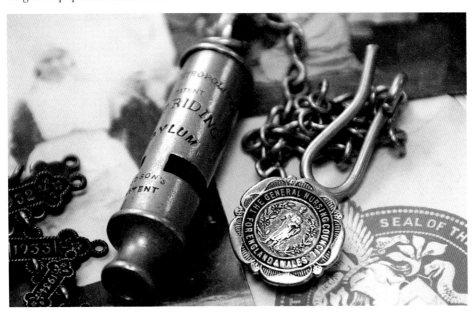

**High Royds Hospital –
Dr Roy P. Hullin, c. 1981**
Pictured left in 1981 is Dr Roy
Hullin and his wife Freda. Dr Hullin
pioneered the treatment of the manic
depressive (bipolar) with lithium at
High Royds Hospital. It was through
Dr Hullin's research that High Royds
gained an international reputation
in the field of biochemical research
into mental disorders, after he set
up the Metabolic Research Institute
in Escroft Clinic in 1962. Treatment
with lithium had dramatic results,
holding out a hand of optimism
as cure and release for thousands
of people became a reality where
previously there had been little hope.
Dr Hullin was also responsible for
both researching and writing the
excellent centenary brochure of 1988
packed full of the former asylum's
historic past. Roy is seen below with
Freda at their home in Leeds in 2010.

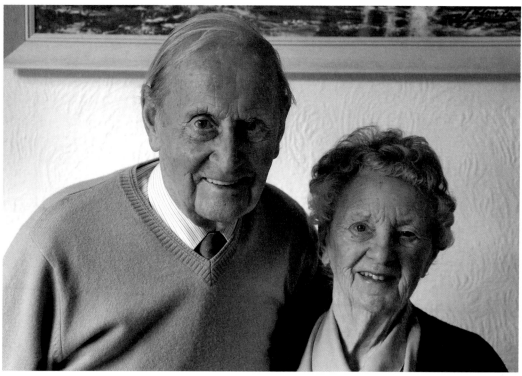

High Royds Hospital – *Black Daisies for the Bride, c.* 1993

Black Daisies for the Bride, written by poet Tony Harrison, was first aired on British television just prior to Alzheimer's Week in July 1993. The film, named after the black daisies prominent in the intricate mosaic in the central corridor of the administration building, focuses on three real female Alzheimer patients resident in Whernside, ward 27. The effect of the fifty-five-minute screen adaptation was to draw the viewer into the horrifying world of the Alzheimer sufferer, which at times was almost too painful to watch. In 1994 it won the documentary special prize at Prix Italia and the best drama at the Mental Health Media Awards the same year.

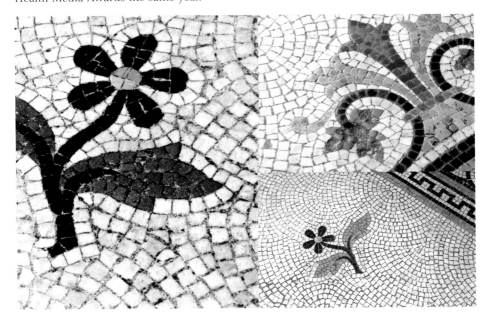

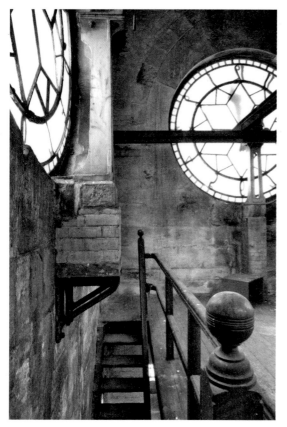

High Royds Asylum – The Filmset

By 2003 all of the former West Riding Asylums had closed their doors. The corridors, once buzzing with activity, lay empty, the wards deserted. With the movement towards care in the community in full swing residential patients were moved to smaller purpose-built accommodation. After closure High Royds was chosen as the filmset for *Asylum*, the movie starring Sir Ian McKellan and Natasha Richardson. The film ended with Stella played by Natasha throwing herself off the top of the magnificent clock tower. Tragically Natasha Richardson died in March 2009 as a result of a skiing accident. The clock face and movement was installed in 1887 by Leeds clockmaker William Pott's. The company were renowned for their installations in cathedrals, churches, town halls, schools, engineering works and railways both home and abroad.

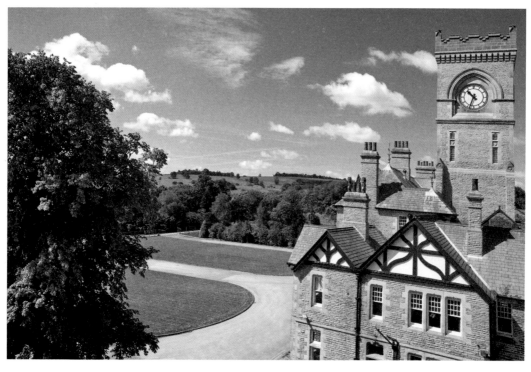

High Royds Memorial Garden

So who were these patients that lived within these vast institutions? The answer is simple, people like you and me. Ordinary people like James Metcalf, pictured right. The patients came from many walks of life: policemen, teachers, millworkers and weavers to name but a few. The Victorian asylum provided for the care of the pauper insane, and many of these people became paupers as a result of their mental illness. They were proud people who had fallen on hard times, lost their jobs or suffered depression after losing a loved one and found themselves abandoned by their families either by poverty or fear of being stigmatised. When death eventually came the asylum provided a pauper grave if the family failed to pick up their relatives remains. Between 1890 and 1969 a total of 2,861 people including James were buried at Buckle Lane Cemetery in unmarked graves three deep.

John Constantine – Menston Asylum

Although John was admitted to Menston in 1889, he was a transfer from the North Riding Asylum where he had been since June 1872 aged just ten. John was both deaf and dumb; the case books indicate he was reduced mentally yet capable of working unsupervised on the farm for many years quite cheerfully. Although understanding what was said to him, others could not understand him, rendering derogatory terms such as 'this dummy patient' and 'a fairly good imbecile'. He would make an effort to speak which was noted in the casebook as 'rather amusing to observe'. John died in 1927 and was buried at Buckle Lane on 16 March, row 28, grave 11, aged sixty-five. John had spent fifty-five years under the banner of care and treatment. Sadly John's story is not uncommon. It is with the assistance of Wakefield Archive Service that we have been able to reunite many families searching for their long-lost relatives. Pictured left is John soon after his reception into Menston. John is again seen below in an updated photograph taken around twenty years later in 1911. (High Royds Hospital collection c488)